PAINTING WITH

PASTEL

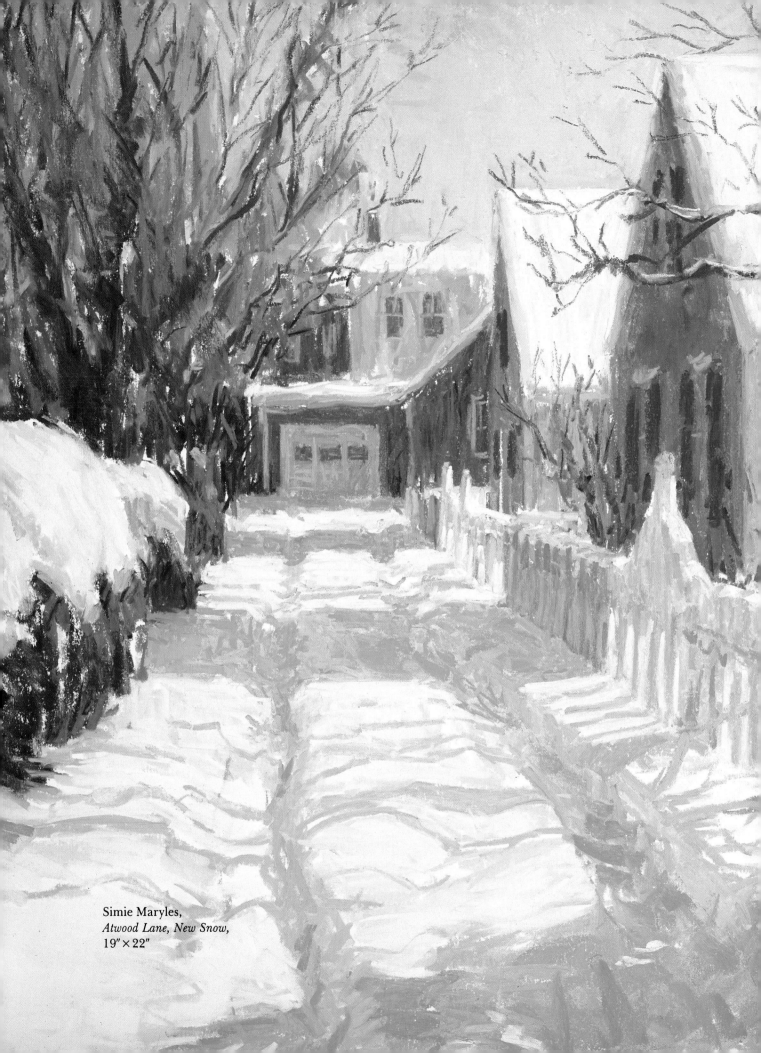

Simie Maryles,
Atwood Lane, New Snow,
19" × 22"

CREATIVE
PAINTING WITH
PASTEL

CAROLE KATCHEN

NORTH LIGHT BOOKS
CINCINNATI, OHIO

About the Author

A professional artist for over thirty years, Carole Katchen has been awarded the Master Pastellist designation by the Pastel Society of America. Her paintings have been honored in galleries and museums throughout the United States and South America. She has written sixteen books, which together have sold over one million copies. Her most recent books include *How to Get Started Selling Your Art* and *Painting With Passion* (North Light). She is listed in *Who's Who in the World*, *Who's Who in American Art* and *Who's Who of Women in the World*. She lives in Hot Springs, Arkansas.

Creative Painting with Pastel. Copyright © 1990 by Carole Katchen. Printed and bound in China. All rights reserved. No part of this book may be reproduced in any form or by any electronic or mechanical means including information storage and retrieval systems without permission in writing from the publisher, except by a reviewer, who may quote brief passages in a review. Published by North Light Books, an imprint of F&W Publications, Inc., 1507 Dana Avenue, Cincinnati, Ohio 45207. First paperback printing 1997.

01 00 99 98 97 5 4 3 2 1

Library of Congress Cataloging-in-Publication Data

Katchen, Carole
 Creative painting with pastel / Carole Katchen.
 p. cm.
 ISBN 0-89134-789-5
 1. Pastel drawing—Technique. I. Title.
NC880.K38 1990 90-34854
741.2'35—dc20 CIP

Edited by Greg Albert and Rachel Wolf
Designed by Sandy Kent

Pages 132-133 constitute an extension of this copyright page.

Christian Heckscher, *Tonight at Vancouver,* 31″ × 41″

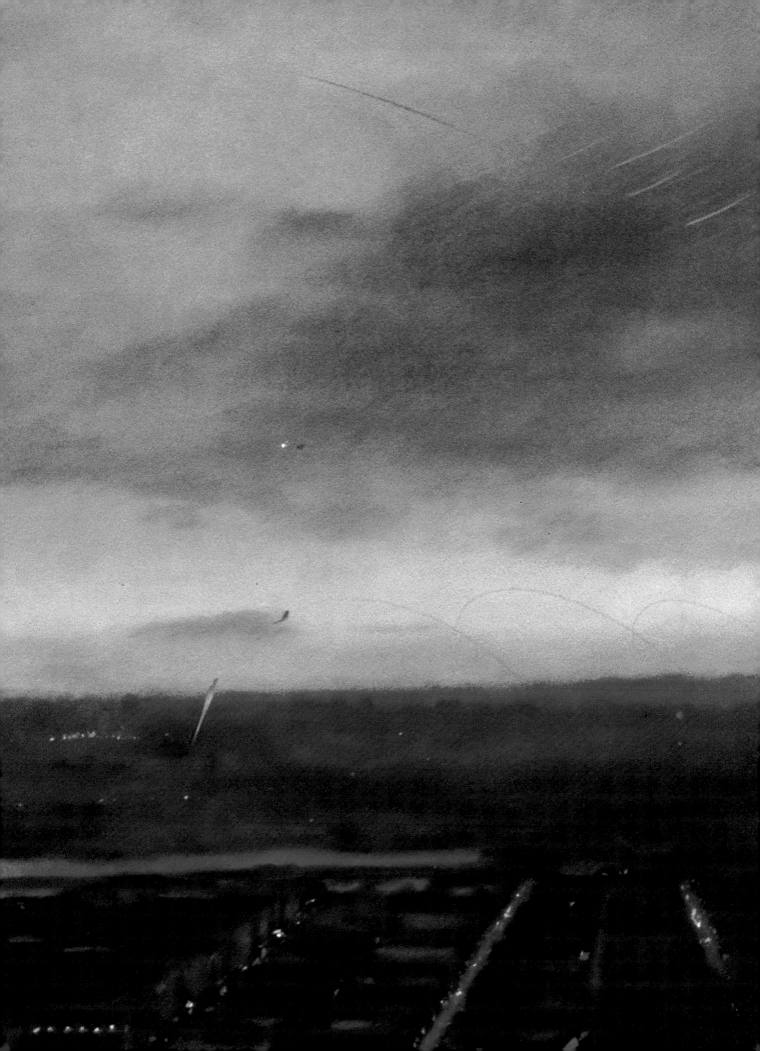

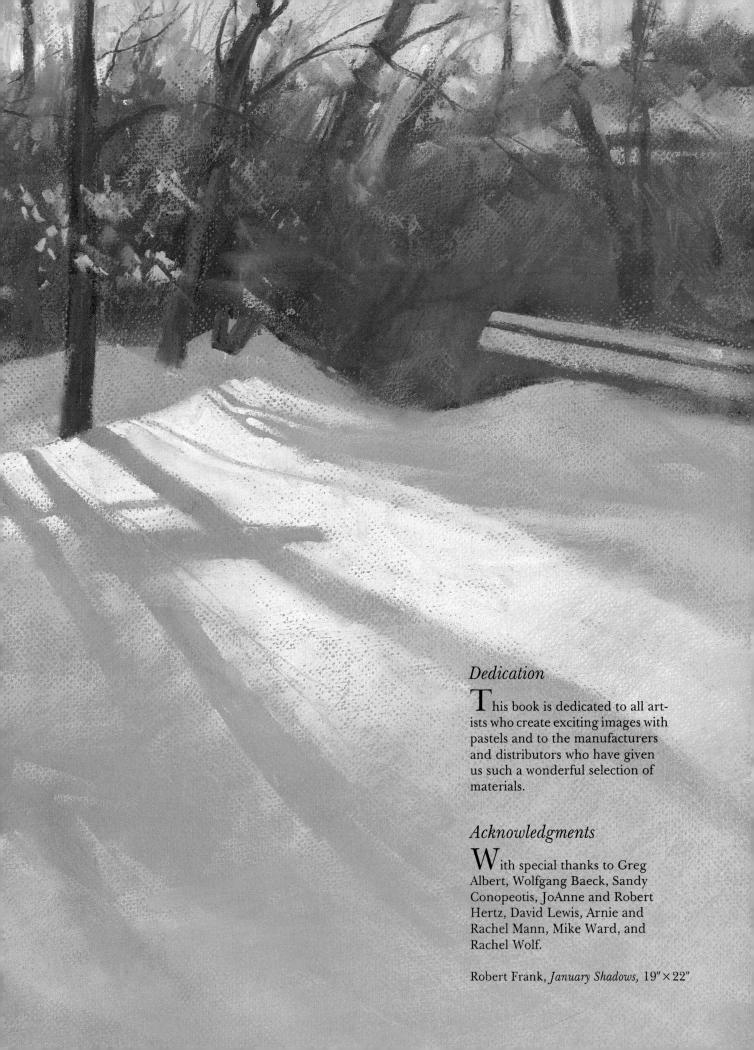

Dedication

This book is dedicated to all artists who create exciting images with pastels and to the manufacturers and distributors who have given us such a wonderful selection of materials.

Acknowledgments

With special thanks to Greg Albert, Wolfgang Baeck, Sandy Conopeotis, JoAnne and Robert Hertz, David Lewis, Arnie and Rachel Mann, Mike Ward, and Rachel Wolf.

Robert Frank, *January Shadows*, 19″ × 22″

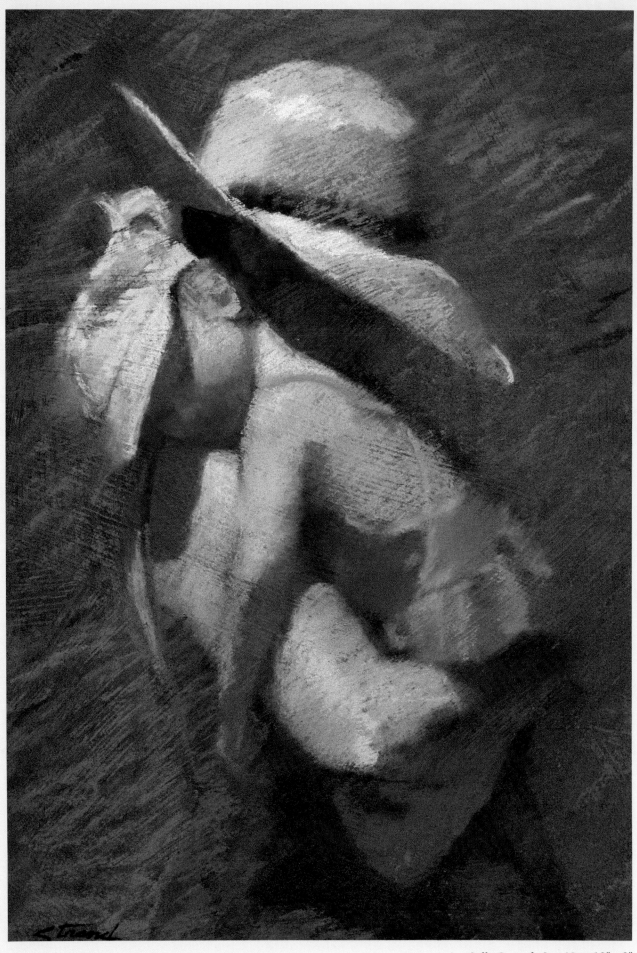

Sally Strand, *Sun Nap*, 13″×9″

CONTENTS

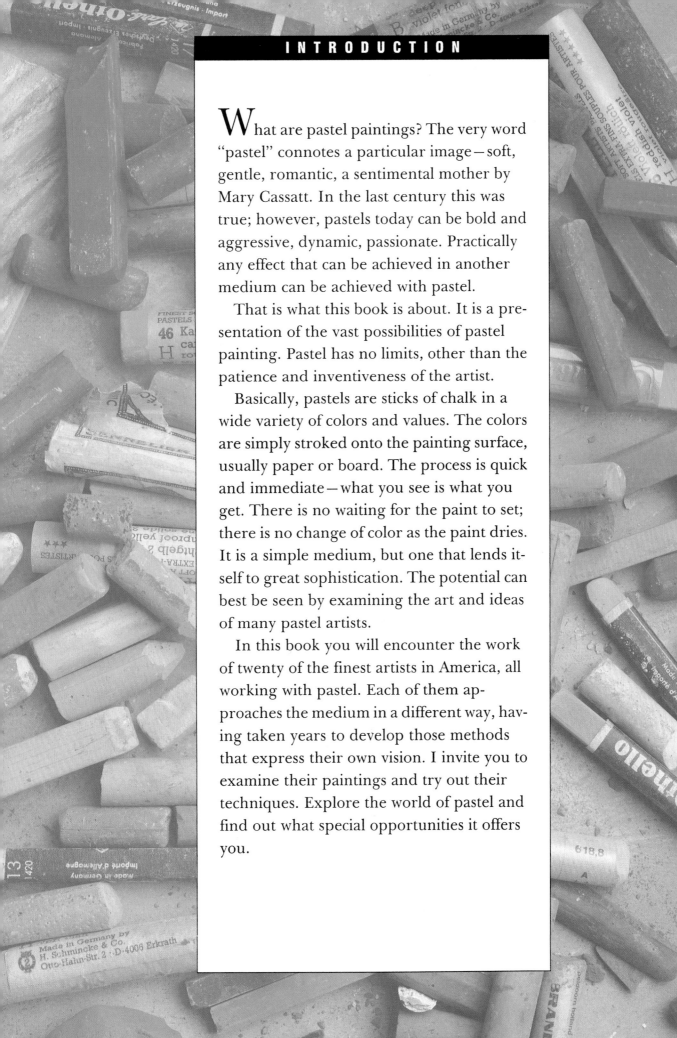

What are pastel paintings? The very word "pastel" connotes a particular image—soft, gentle, romantic, a sentimental mother by Mary Cassatt. In the last century this was true; however, pastels today can be bold and aggressive, dynamic, passionate. Practically any effect that can be achieved in another medium can be achieved with pastel.

That is what this book is about. It is a presentation of the vast possibilities of pastel painting. Pastel has no limits, other than the patience and inventiveness of the artist.

Basically, pastels are sticks of chalk in a wide variety of colors and values. The colors are simply stroked onto the painting surface, usually paper or board. The process is quick and immediate—what you see is what you get. There is no waiting for the paint to set; there is no change of color as the paint dries. It is a simple medium, but one that lends itself to great sophistication. The potential can best be seen by examining the art and ideas of many pastel artists.

In this book you will encounter the work of twenty of the finest artists in America, all working with pastel. Each of them approaches the medium in a different way, having taken years to develop those methods that express their own vision. I invite you to examine their paintings and try out their techniques. Explore the world of pastel and find out what special opportunities it offers you.

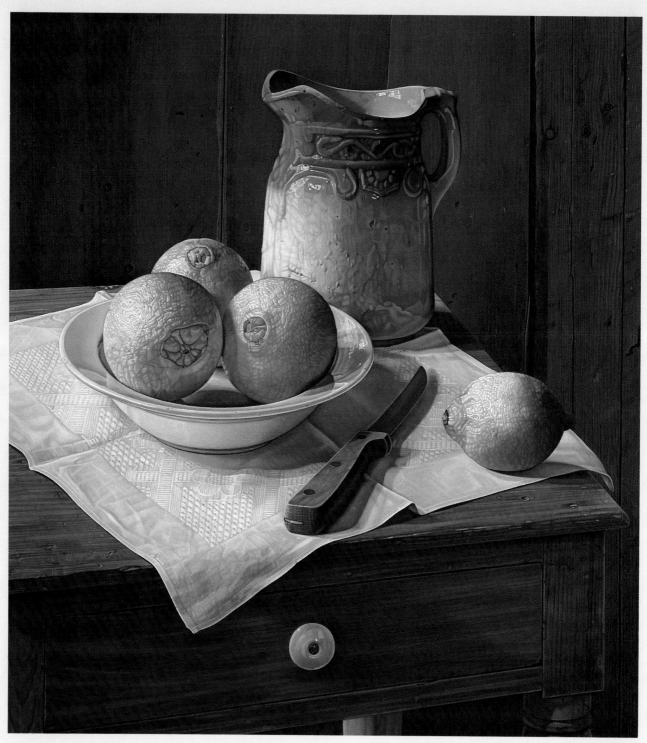

Jane Lund, *Still Life With a Blue Pitcher*, 22″×20″

VERSATILITY
The Beauty of Pastel

Because of the vast range of ways to use pastel, it is a medium suited equally well for the beginner or the accomplished artist. Artist Sidney Hermel explains why he uses pastel: "I started my art career in oils and gradually shifted to watercolor for my outdoor work, but in pastels I found the best of both mediums—directness of execution, brightness, and vibrancy. Once I really got into the pastel medium, I was 'hooked' and at the present time I use this delightful medium almost exclusively.

"The question usually arises as to why one would choose this medium over 'king' oil. Pastels are a dry, direct medium. I feel the pastel stick is an extension of my fingers and I need no brush to come between me and my panel, canvas, or board. Furthermore, no medium is required, nor do the colors sink in as in oil or fade as in watercolor.

"Pastels are durable and permanent because they are pure pigments with some inert binder. They do not deteriorate, and if handled properly (that is, if they're placed under glass) will last indefinitely. For example, there are museums throughout the world that are exhibiting pastels that are hundreds of years old and do not show any sign of losing their brilliance.

"We have in pastels the best of all possible worlds—speed, directness of execution, permanence, and brilliance of color."

Sidney Hermel's art vibrates with the spontaneity of on-the-spot painting. In his scenes of New York and Europe he portrays the color

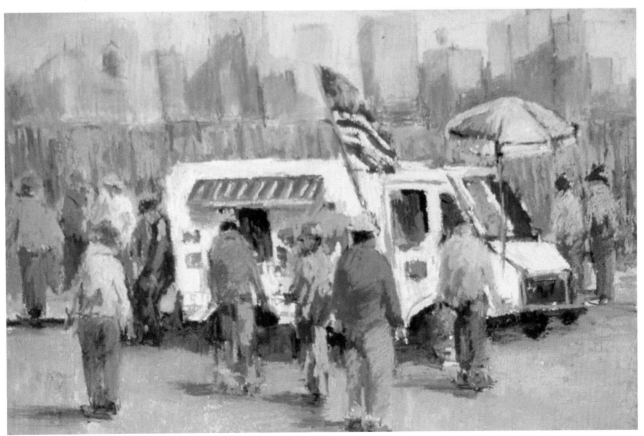

Sidney Hermel, *Lunch Break #2,* 14" × 18"

Pastel is an excellent vehicle for the loose, expressive paintings of Sidney Hermel. He captures the movement and spontaneity of a moment with individual strokes of color that provide surface texture as well as creating an image.

Jane Lund, *Gourds and Onions,*
14″ × 15½″

*Lund took eleven months to complete this
small painting. She covered her studio
windows with black plastic so her one in-
candescent bulb would be the only light
source on the still life. She is pleased with
the result, but says that working in such
great detail was difficult in such a small
format.*

and movement of the streets
around him with bold strokes
rather than careful rendering. The
speed and directness of pastel are
perfect for capturing these kinetic
images.

But, can it also work well for the
meticulous draftsman? Ask Jane
Lund, who routinely devotes many
months to a single pastel painting.
Her paintings are unmistakable for
the virtuoso rendering of detail.
The wrinkles of an orange peel, the
grain of a barn wood wall, the
woven pattern of a linen napkin—
these are the stuff of her pastel
paintings.

Lund says, "I paint in pastel pri-
marily because I consider myself a
draftsperson and the medium
lends itself to a drawing concept.
The technique I developed has en-
abled me to make 'paintings' in a
dry medium, eliminating the need
for glazes, varnishes, and the like.

"Working with pastels has its
drawbacks, however, such as the
fragility of the medium and all the
attendant problems in framing and
shipping. For me, though, the lu-
minous, softly glowing surface that
can be achieved more than com-
pensates for these difficulties.

"When I first began using it, pas-
tel seemed to be a simple medium,
one that I could explore for myself.
As I am largely self taught, I was
able to grow with this medium
without feeling too intimidated by
a complicated technical agenda."

Hermel and Lund are highly
skilled artists, experienced in con-
trolling value, color, composition,
and stroke. They each have a
highly developed personal style.
Can the medium that works so
well for them also be right for the
beginner?

Yes, says pastellist Doug Daw-
son, who regularly teaches students

how to express their art in pastel.
Dawson is known for his expressive
paintings of figures, landscapes,
and city scenes. In his classes he en-
courages each student to find his or
her own vision.

Dawson says he uses pastel with
his students because "it is fast (it
covers large areas quickly), it is im-
mediate, and it encourages experi-
mentation. Pastel has an immedi-
acy—there is no drying time and
no color change due to drying. Stu-
dents can see immediately what it
looks like.

"It is an ideal material for learn-
ing to handle color, because you
cannot mix the pastels with the
same facility that you can mix liq-
uid colors. You have to mix new
colors *within* the painting, creating
those colors by juxtaposing and
overlaying existing colors. You
are forced to make new color
discoveries."

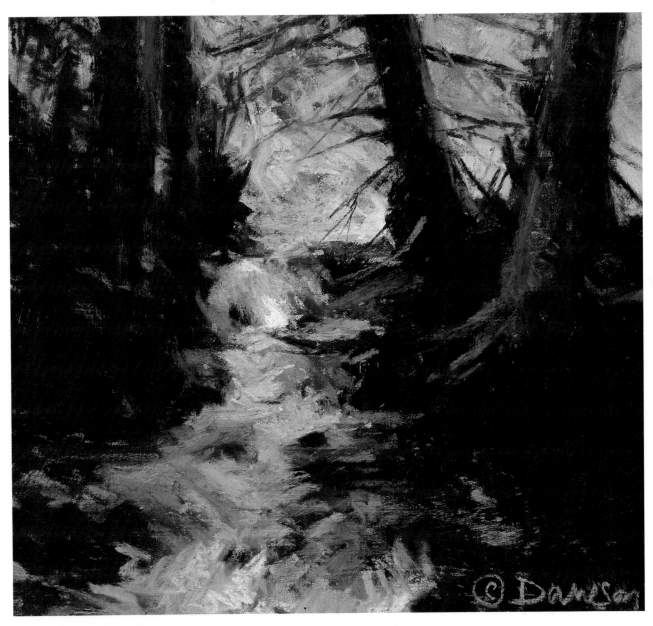

Doug Dawson, *Going up Berthoud*, 14″ × 15″

*For Doug Dawson even a simple mountain stream becomes a powerful statement with
the bold contrasts of color and value in his pastel strokes.*

The advantage for the beginner is the simplicity of the medium; with only a handful of colors and a sheet of paper it is possible to create a painting rich in color and texture. For the artist who wants more, pastel can be enriched by using a variety of surfaces—different papers, boards, and even cloth. It can be diluted with water or turpentine and can be mixed with other media.

Each artist develops a personal "handwriting" with pastel. Some paint with bold individual strokes, letting the lines or dots of separate color vibrate against each other. Some paint with layers of lighter strokes that merge into new colors on the surface of the painting. Still others put down strokes of pastel and then blend them with fingers or cloth to create a smooth surface of uninterrupted color.

The hardness or softness of the pastel stick will vary the character of the stroke. The artist can achieve thin, precise lines and details by using pastel pencils or sharpened sticks of pastel. Turning the pastel stick on its side produces wide strokes for covering a large area quickly. Repeated directional strokes, as in crosshatching, can be used to establish surface texture, depth, shape, and value.

When the strokes are smoothed out with fingers or cloth, transparent layers of color can be developed. Pastel can be used like watercolor or thinned oil, built up gradually in layers of glazes. This

Sally Strand, *Picnic*, 30″ × 40½″
Strand's favorite subjects are people in sunlight. With pastel's full range of values she is able to convey the dramatic contrast between strongly highlighted and shadowed areas.

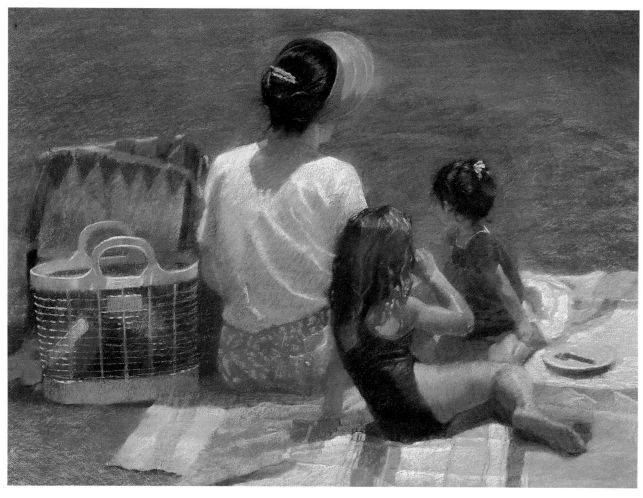

Simie Maryles, *Side Gardens, End of Summer,* 23¼″ × 19″

Maryles builds a tapestry of color on her paper. Her scenes, which look quite solid at a distance, are actually composed of many small strokes of color left for the eye to blend.

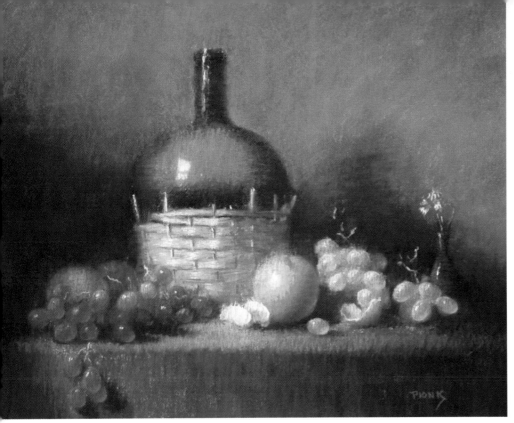

Richard Pionk, *Oranges and Wine*, 20″ × 25″

The use of very soft pastels and a panel of museum board, gessoed for a strong tooth, enabled Pionk to build up many layers of pastel to get the rich colors and textures of this painting.

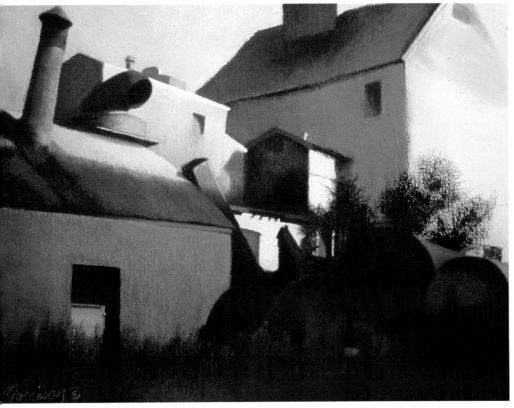

Mary Morrison, *The Mill*, 29½″ × 40″

With pastel this artist can revise and refine her composition during the painting process. By fixing each layer of pastel before she adds the next colors, she is able to keep the surface fresh for reworking shapes and values.

use of glazing is especially successful in the blending of colors. Because pastel is a dry, solid medium, it cannot be blended into new colors on the palette. So the artist must take existing colors and blend them together on the painting surface. This is done by rubbing strokes together, or by overlaying strokes, or by merely placing various colored strokes next to each other. This last technique creates a vibrant surface that, when seen from a distance, is blended into a solid color by the eye.

The broad scope of the medium induces experimentation. And pastel is very forgiving. There is no mistake that cannot be repaired. The dry pastel can be lifted or rubbed off with an eraser or brushed off with a cloth or hard-bristle brush. A section of the painting can be sprayed with workable fixative returning the surface to a receptive state.

Perhaps the most effective way for me to convey the tremendous versatility of pastel is to show you the pastel paintings of artists who work in dramatically different styles. Look at the work of the next three artists — Robert Frank, Jody dePew McLeane, and Edith Neff — to see how each of them has adapted pastel to show their own view of the world.

Frank is an impressionist — he combines the smoothness of blended color with the sparkle of individual strokes to achieve gently atmospheric pictures. McLeane, an expressionist, pushes pastel to its limits of intense color and stroke for maximum emotional impact. Neff is a classical realist. For her, the medium is merely the best way to express the image. She uses architectural subjects to devise a strong design.

With pastel all three of these artists can create images that are personally satisfying.

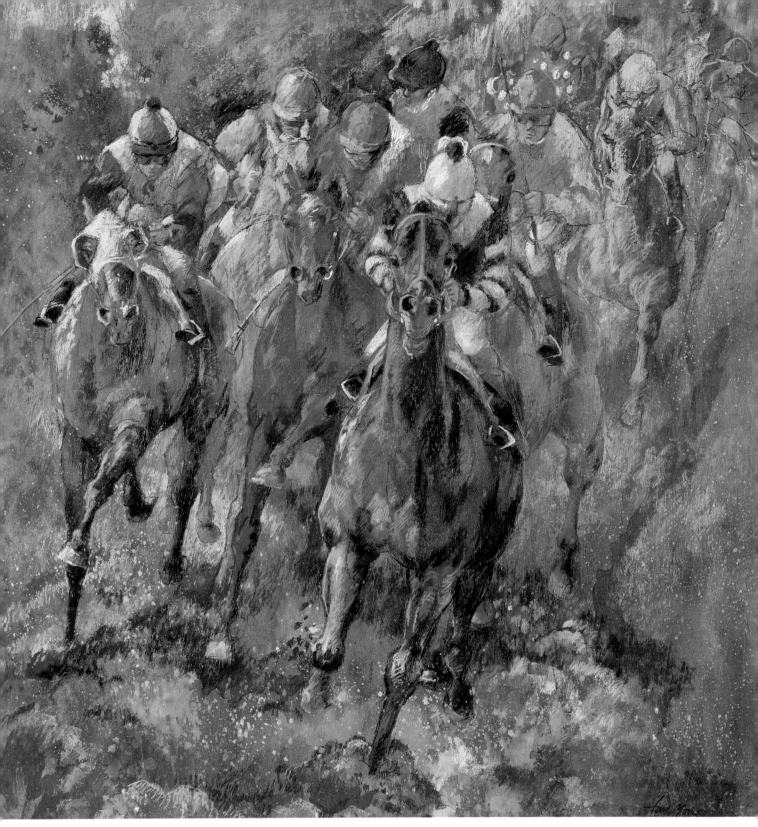

Fay Moore, *Seattle Slew, 38″ × 38″*

Fay Moore shows the excitement of a horse race in action with vibrant surface textures.
She combines watercolor with pastel, using washes, splatters, and bold strokes of color
to build her moving image.

Painting the Charm of Impressionism

ROBERT FRANK

Surrounded by the lush Ohio countryside, Robert Frank fills his paintings with the romantic imagery of nature. He follows the seasons, portraying trees and streams in all weather and all light. His palette leans toward softer colors, delicate blues, greens, and pinks with an occasional stroke of more intense color as an accent. In each image he strives for grace and elegance of form and color.

Pastel works well for him because he is able to lay in smooth, large shapes with a softness that creates the mood. Then he can punch out the stronger, more defined trees and shadows in darker values to give his pictures greater drama. "My personal application is painterly, much like a watercolor or oil painting."

Frank uses many different types of surfaces and these affect his pastel application. A favorite ground is Canson pastel paper, though he also paints on sandpaper, gessoed paper, or board. He says, "My approach is to organize color masses and define large shapes. A painting can be successfully stated within the first fifteen minutes and then everything after that is pure fun. Simplicity is the key when the painting is first formulated.

"I try to get a strong stroke like oil painting with a bristle brush, where you push hard and pull up at the end. I put pressure on the pastel stick at first and then let up on it. I might rub the end of the stroke with my finger or a cloth."

Frank adds, "Newcomers to pastel are usually searching for 'tricks' or shortcuts to accomplish an acceptable painting, but unfortunately this path leads nowhere. Pastel is no different than any other medium. You must learn the basics of drawing and painting and then practice, practice, practice."

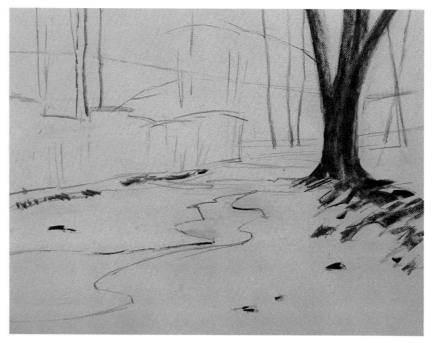

Step 1: *The basic drawing is done with charcoal on reddish Canson paper and then spray fixed. Note he has chosen to use the rougher textured side.*

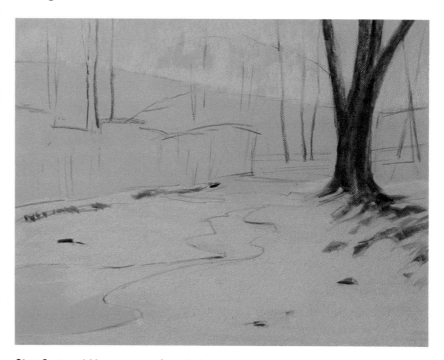

Step 2: *A cool blue-green underpainting is applied with broad strokes, using the side of the pastel stick. The blue-green looks cooler because it is applied over a warm color. Again spray fix is applied.*

10

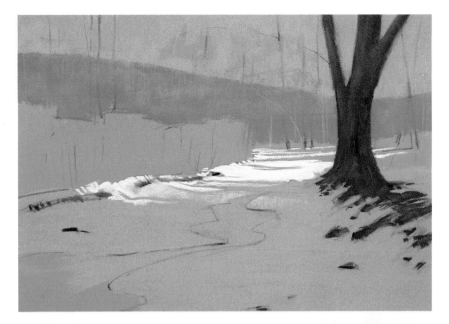

Step 3: *Background red-purple is added. This intense color will be toned and modified later. The lightest shade of yellow is added for value reference. Now the full range of values is established and again spray fix is applied. Notice that the paper is still very much a part of the picture.*

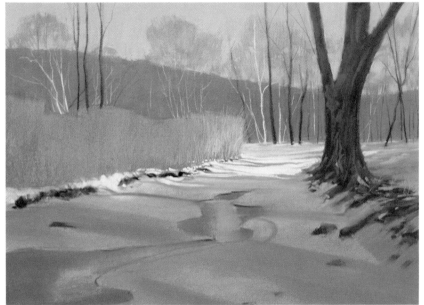

Step 4: *Color balance is refined with the addition of more colors, keeping the values under control and still utilizing the tone of the paper. The sky, tree trunk, and foreground are defined. There will not be much alteration from this point on, so every stroke counts toward the final result. No more spray fix will be added to the picture.*

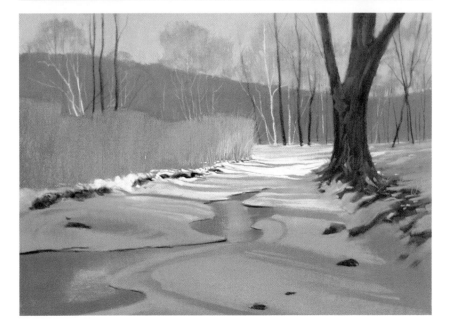

Step 5: *Secondary tree trunks are added to the background in lighter values to show recession of space. More details are established in the brush along the stream and the water itself. At this point he rubs some sections with his fingers to create passages between colors or to lose the paper texture. When blending he is careful not to lose the expression of important strokes.*

Robert Frank, *Bellbrook Creek in Winter*, 19″×25″

Step 6: *Final details are added such as tree branches. A lighter glaze is painted over the purple background to make it recede and provide more contrast with the foreground ice and snow.*

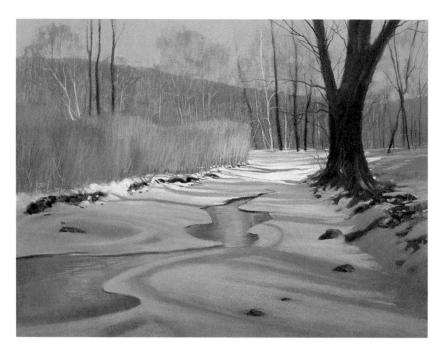

Robert Frank, *Morning Marsh*, 21″×29″

Close examination reveals the wonderful variety of strokes Frank uses. Some of the very muted colors are the result of underpainting with turpentine and pastel.

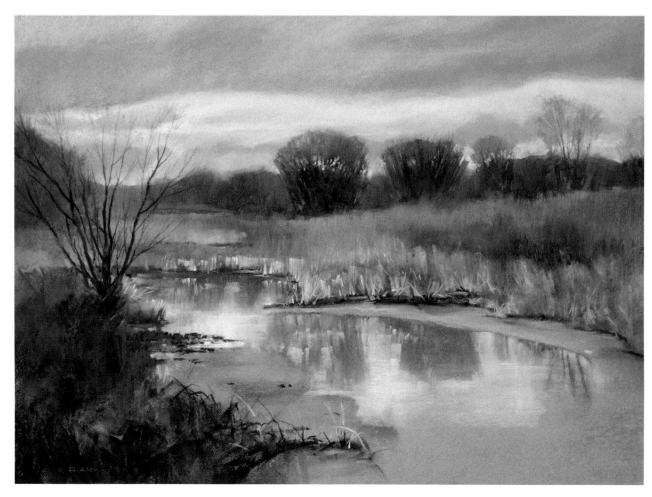

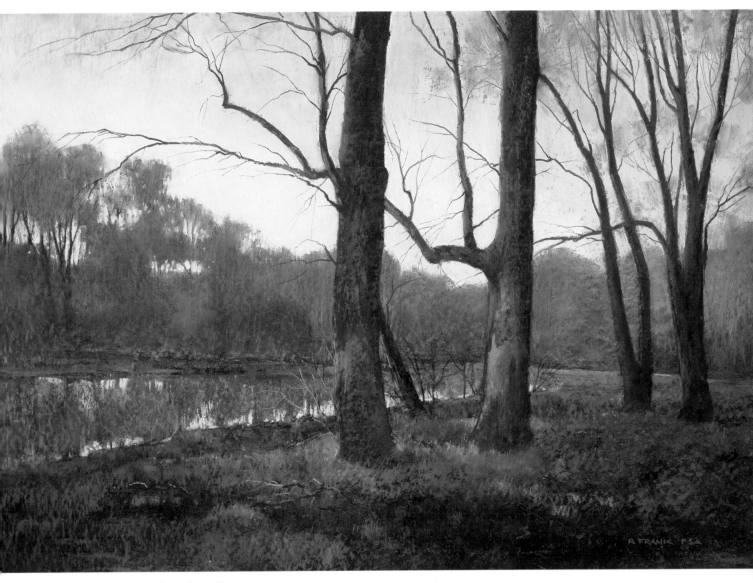

Robert Frank, *Daybreak on the Still-water*, 24″ × 32″

Notice how the smoothness of the background colors contrast with the stronger individual strokes in the foreground to give a sense of depth.

A Lively Expression in Pastel

JODY dePEW McLEANE

In contrast to the peaceful country paintings of Robert Frank are the lively everyday subjects of Jody de-Pew McLeane. McLeane uses bold, spontaneous strokes and colors to create emotional impact. She uses very soft pastels, knowing she can alter or reverse an effect with additional strokes of the "buttery" sticks of color.

She says, "The heavy layering of soft pastel as well as the 'brush stroke' give the drawing a painterly appearance. These open strokes add to the impression of catching the moment of an unpretentious everyday occurrence."

From the beginning, this artist uses intense colors that look or feel right to her. Colors and values are exaggerated and realistic details are only suggested so realism is always secondary to the dramatic impact of a painting.

Pastel suits the style of McLeane because of its immediacy and the luminous colors. She says, "I began using pastel as a first step in my painting process—going to a location to do a landscape or a water sketch, which I would later translate into an oil in the studio. I soon found more excitement in working with pastel than oil and stopped the oil painting entirely. I love the action that can be created on the surface of the drawing."

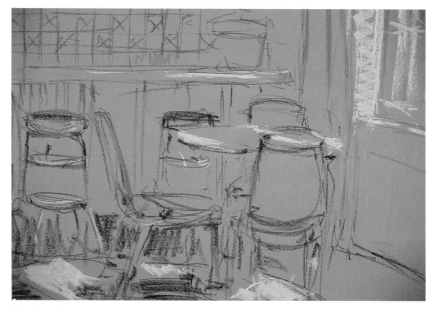

Step 1: *Working with Rembrandt pastels, McLeane quickly blocks in the composition. She is drawing on felt gray Canson Mi-Teinte mounted on four-ply board. McLeane does not underpaint or use any liquid medium to dilute the pigments.*

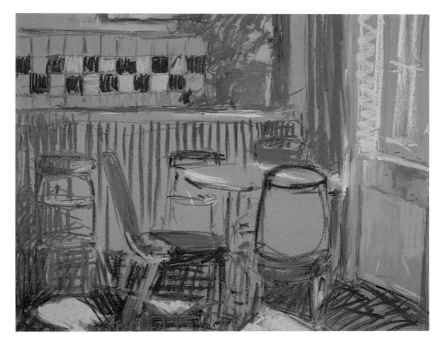

Step 2: *With Sennelier soft pastels, she lays in the darkest areas with browns, purples, and reds, as well as greens. She uses a crosshatching of strokes so each color will remain visible.*

14

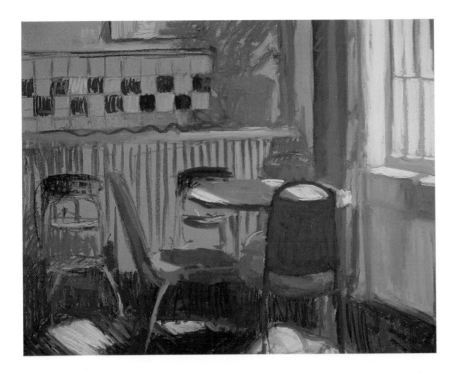

Step 3: *Next she works in broad strokes of vibrant reds with the German Schmincke soft pastels on the chair closest to the viewer. No fixative is used. The window and drapery are worked; dashes of pink are added on the bar stools and under the window. McLeane is careful not to overwork any one area at this point.*

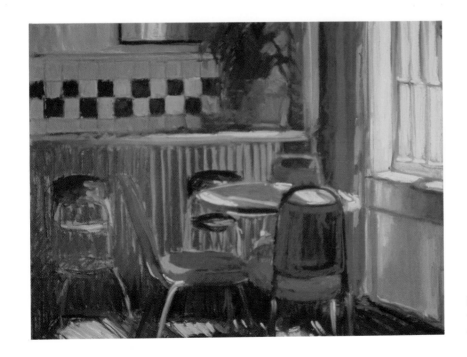

Step 4: *Here McLeane is developing values and adding darks and colorful strokes indicating the strong natural light.*

Step 5: *McLeane works intuitively, adding bits of color where she feels the painting calls for it: the stools, the drapery, and the chair seats.*

Jody dePew McLeane, *Window Table,* 26″ × 32″

Step 6: *In the final stage, McLeane softens the hard edge between light and dark in the drapery and further refines her colors.*

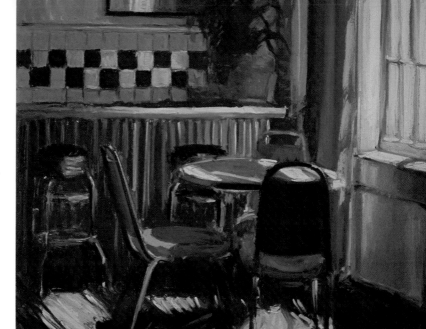

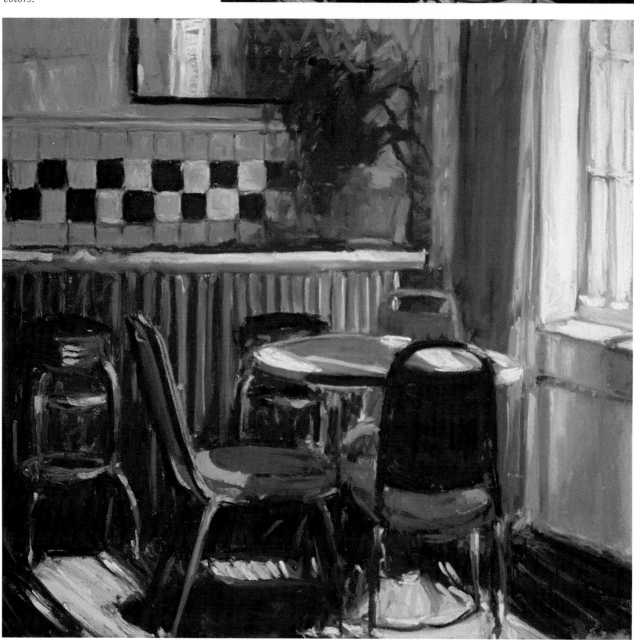

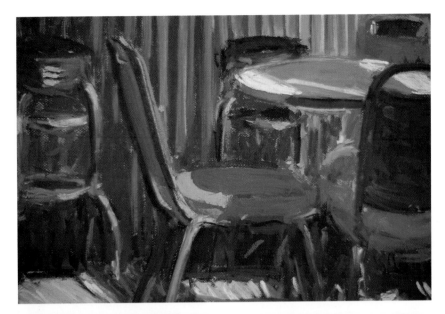

Detail: *In this detail you can see the bold strokes McLeane prefers.*

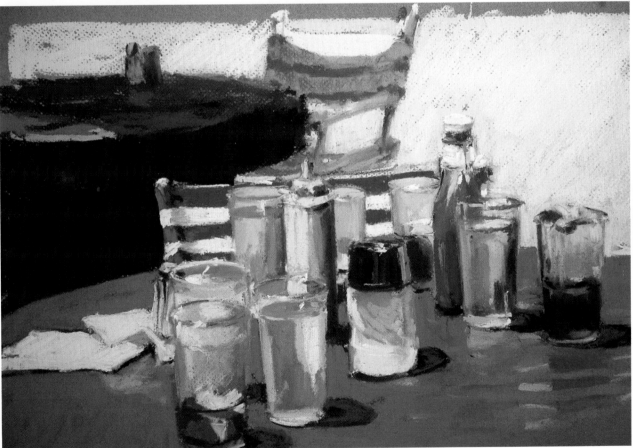

Jody dePew McLeane, *Blue Table/ Striped Chairs,* 16″×20″

What would otherwise be a mundane still life becomes a powerful painting because of the strong strokes and colors. McLeane has used very soft Schmincke pastels here for her top layer of color, filling the deep tooth of the Canson paper.

Painting Precise Details

Step 1: *Neff begins with a precise drawing in compressed charcoal. She determines composition and scale by studying sketches and photos she has made of the subject.*

Step 2: *She begins painting with a loose layer of pastel all over the paper in local color: red on the roof, yellow for the boards, green for the foliage.*

EDITH NEFF

The buildings that Edith Neff chooses to paint are more like old friends than cold structures of brick and mortar. She never chooses a building quickly, but goes back again and again to look at it in varied light and weather conditions. She takes many photographs, watching how the forms change in different light.

She begins her composition with a very careful charcoal drawing because for her the essence of architecture is detail. She carefully notes shapes, angles, and textures. The drawing remains important through all phases of the painting process.

Her painting process is a matter of building up many layers of individual strokes until the picture has the color, value, and density that she wants.

Neff says, "I work in pastel for many reasons. I have always loved to draw, and the pastel medium is a way of combining the gesture of drawing with the color of painting. Much of my work is involved with the patterns of light and shadows on buildings, and the intensity of color in pastel is unmatched by any other medium.

"One last reason is my interest in architecture and the quality or feel of materials such as stonework, shingles, marble, cement, or slate. Pastel is a medium that depends on a sense of touch. I feel most able to convey the touch or feel of buildings with pastel."

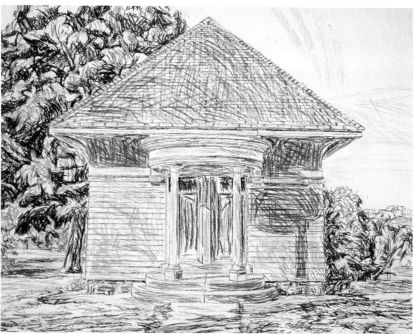

Step 3: *As she adds more layers of loose strokes, the underdrawing becomes obscured. Because the details established in this drawing are so important, she periodically reinforces the drawing with a softer grade of compressed charcoal that is more compatible with soft pastel.*

18

Step 4: *She enriches her colors by using many tones and shades in each area. In the roof there are strokes of red, burgundy, and pink; in the shadows, brown, violet, and green. These will blend visually to create an impression of solid color.*

Step 5: *As her pigment becomes denser, she concentrates on value as well as color. Value contrast is essential for showing the three-dimensional sense of architecture and foliage.*

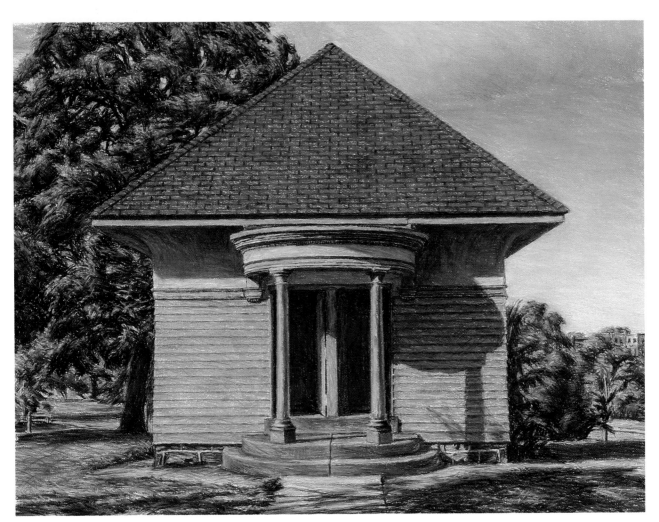

Edith Neff, *Lemon Hill,* 25″ × 32″

Step 6: *Although the finished painting has a very solid look to it, it is still composed of many small, overlapping strokes of color. The basic architectural form and details are indicated by the black charcoal lines still visible in the finished painting.*

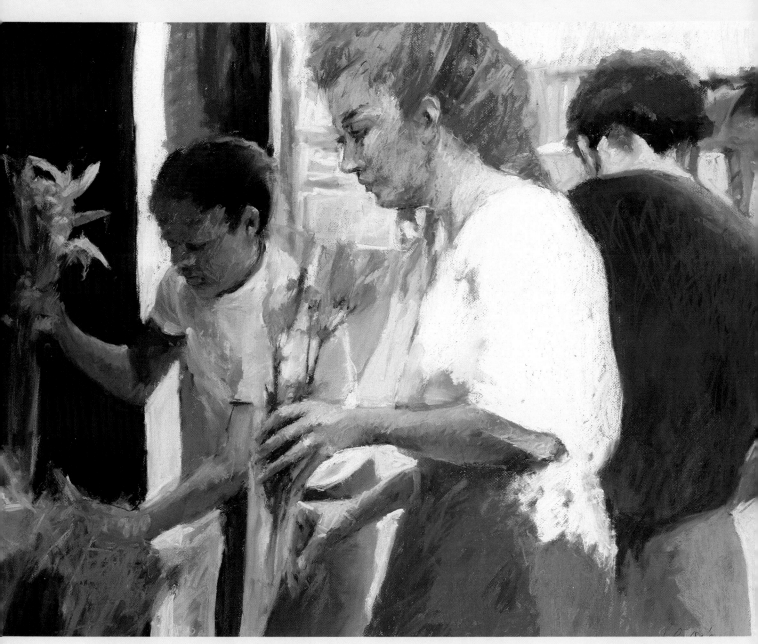

Jody dePew McLeane, *Woman with Red Hair*, 32″×40″

MATERIALS
The Tools of the Trade

As in any medium, the choice of materials affects the final image. With pastel, there are many variables to consider. These include the hardness of the pastel sticks, the texture of the paper, the use or non-use of fixative—each of these will have a different effect on your finished painting.

First are the pastel sticks themselves. Pastels are made by combining powdered pigment with gum binders, rolling the mixture into sticks, and letting the sticks dry. The more gum, the harder the pastel stick. The hardness is also affected by the white or black powder used to extend the pigment and determine value. The white is generally softer and the black harder.

The hardest pastels will scrape across the surface of the paper, leaving very little pigment behind. The softest pastels practically crumble into the paper. Each hardness has its use in developing a pastel painting.

PASTEL PENCILS

The hardest pastels are generally the pastel pencils. With their hard pigment and thin points, these give the greatest control, so they are excellent for drawing. You can vary the width of the line by using a sharp or dull point or the side of the point (sharpen with a knife or sandpaper). You can vary the value of a stroke by applying more or less pressure. To fill broad areas of color you can "feather," drawing many quick, parallel strokes, or "crosshatch," drawing layers of strokes in opposing directions.

Pastel pencils work much like graphite pencils, but they smear more easily. This trait can be used to your advantage in places where you want to soften and blend strokes.

In a painting, pastel pencils are good for the initial drawing and for rendering details. Two cautions: In your initial drawing stage be careful not to apply too much pressure, because the hard pastel pencil can indent or scrape the surface, making it impossible to achieve a smooth finish. Also, when you plan to use pencils for detail later in the painting, avoid heavy build-up of soft pastel in those areas—hard pastel will not adhere well over soft.

HARD PASTELS

The most commonly used hard pastels are NuPastels and Conté Pastel Sticks. Most brands of soft pastels also include some very hard sticks of color. I usually buy my pastels by individual sticks and I test each color to determine its hardness.

Like pastel pencils, hard pastels give great control. They are good for fine lines and details as well as applying thin layers of colored strokes. Hard pastels often come in a square rather than rounded shape, so the corners and edges are

Here is an assortment of the many types and sizes of pastels used by Elsie Popkin.

good for precise work. They can be sharpened to points with a knife or sandpaper. The same cautions apply to hard pastels as to pastel pencils.

SOFT PASTELS

Soft pastels are my favorites, the softer the better. They cover large areas quickly, they blend easily, and with a delicate touch they can also be used for detail.

Many manufacturers make soft pastels and the softness varies greatly. Rembrandt colors tend toward the hard side. Sennelier and LeFranc & Bourgeois are softer and Schmincke are very soft. Most brands also seem to vary in softness from stick to stick. Of the brands I have used, Schmincke alone are consistently of a velvety softness.

Soft pastels also have their disadvantages. Because they go on so easily and tend to crumble with excess pressure, each stick is used up quickly. They also tend to fill the pores of the surface, hiding the paper texture that many artists want exposed for visual interest. And, as stated before, once a strong layer of soft pastel is laid down, it will resist application of hard pastel.

Just as the rule in oils is fat over lean, so the rule in pastel is soft over hard. Resist the temptation to start with ultrasoft pastels, which will clog the paper and make later adjustments difficult.

Elsie Dinsmore Popkin, *Reynolda Gardens—Marigolds and Celosia, 30″ × 38″*
Like most artists, Popkin starts her paintings with her hardest pastel sticks (Rembrandt and Grumbacher), gradually building up to her softest (Diane Townsend).

It's a good procedure to use the hardest pastels to lay in the basic colors, because they are easily covered over with softer pastels such as those made by Sennelier, Girault, Rowney, or Schmincke.

MAKING YOUR OWN PASTELS

For artists who are unable to find suitable pastels, it is possible to make your own, but it is important to take some necessary health precautions. The main shortage among ready-made pastels seems to be soft pastels in dark colors. Jody dePew McLeane has a simple way of making those.

She suggests, "Rich black-reds, -greens and -blues can be made very easily by combining a full stick of Rembrandt black with a *portion* of a soft Sennelier red, green, or blue. The Rembrandt has enough gum binder that when both sticks are ground down to powder and combined with a small amount of water, the paste will roll into a stick form and harden within a day or two."

Madlyn-Ann Woolwich also makes some of her own pastels. She makes some from scratch using basic pigments and gum binders. A quicker method is to "crack a colored pastel with a black pastel, grind the mixture with a mortar and pestle, add alcohol, roll out, and let dry. Whatever the method, it is necessary to wear a good dust mask and rubber gloves to prevent inhalation and ingestion of pigments. The areas should also be kept scrupulously clean."

PASTEL PAPER

There is a wonderfully wide selection of surfaces on which you can paint with pastel. Most pastel paintings are done on paper and the most popular among professionals seems to be Canson Mi-Teinte.

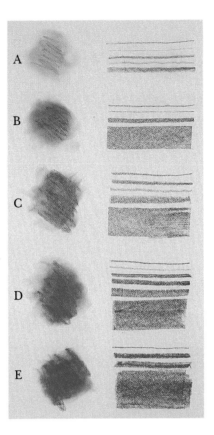

Here you can see the various effects you can get from hard to soft pastels. I have used five sticks of varied softness and made several different types of strokes with each, including a stroke that I blended with my finger to the left of each group of lines. From hardest to softest, top to bottom, they are: A) pastel pencil, B) NuPastel, C) Rembrandt, D) Sennelier, and E) Schmincke.

Jane Lund, *Still Life with Three Eggs*, 20″ × 22½″

In contrast to Popkin, Lund works from soft pastels to hard. (Her softest pastel, Rembrandt, are Popkin's hardest.) She puts down tiny strokes of soft colors and then blends them by working over them with harder Holbein sticks and finally very hard NuPastels for fine detail.

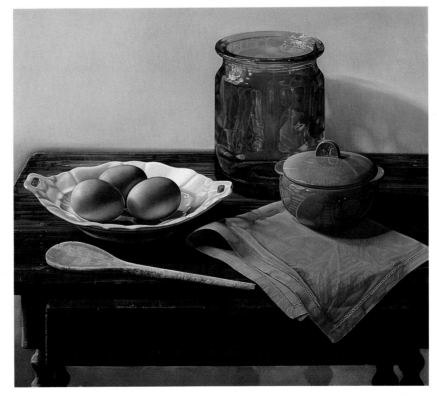

This paper comes in a variety of colors in 19½ × 25½-inch sheets. It is a heavy enough weight to allow some reworking and it provides a good "tooth" or texture to hold pastel. One side is more textured than the other, so you can choose which texture will work best for a particular painting.

Canson also comes in rolls that are approximately 5 × 30 feet, from which the artist can cut the desired size. To eliminate the curve of the paper, Tony Ortega advises you to spray it lightly with water and dry it quickly with a hair dryer.

Fabriano makes a large sheet, called Morilla, that is about 27 × 39 inches. This is my favorite pastel paper. It has a rich tooth and enough body or stiffness to take a lot of abuse.

Duracolor and Artiques (Aquabee) papers are also stiff, textured, and come in a broad range of colors. However, they seem to have a lot of sizing that gives the papers a slick surface. To build up layers of pastel, you must spray with workable fixative between coats of color. Roma paper comes in gorgeous colors with a texture more like the charcoal papers.

There are also many other pastel papers. The best way to find the perfect pastel paper for you is to try many varieties and see how they suit your style.

OTHER PAPERS

Charcoal papers such as Strathmore or Ingres, made by Bienfang, have a wonderful textured surface and a wide range of colors, but they are thinner and require more care in handling.

For a smoother surface, try etching or other printmaking papers. These work well for a smooth, blended style of pastel painting. For a roughly textured look, try

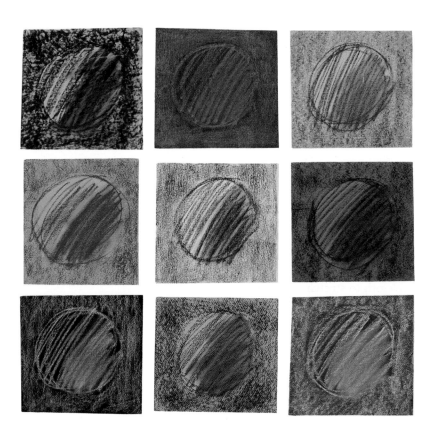

This shows how various strokes look on samples of nine different papers left to right, top row first: 1) Starcke snuffing (sand) paper, 2) Hermes sanded cloth, 3) Ingres Antique charcoal paper, 4) Rives BFK etching paper, 5) Arches Cover etching paper, 6) Strathmore charcoal paper, 7) Fabriano Morilla pastel paper, 8) Aquabee Artique pastel paper, and 9) Canson Mi-Teinte pastel paper.

The sandpapers "grab" the pastel pigments for dense colors. The charcoal papers have a linear texture and on those and the Artique the strokes blend easily. The etching and pastel papers have deep textures to hold pigment and give an interesting surface. The only way to know which papers are best for your own style is to try several.

rough watercolor paper—these work especially well if you are using an acrylic or watercolor underpainting.

Sidney Hermel often paints on sandpaper. He uses two German brands—Starcke, a smooth sanded paper called "snuffing" paper, and Hermes, a sanded cloth with a rougher texture. He says he does not know how permanent they are, but paintings twenty to twenty-five years old show no sign of deterioration. "The sanded surface is an advantage because its tooth holds more pastel as the painting progresses. However," he cautions, "water-based mediums are not possible for underpainting here

because the water disturbs and removes the gritty surface of the paper. Therefore, the use of oil paints, thinly diluted with turpentine, is advised."

Diana Randolph paints on Grumbacher sanded pastel paper. She covers areas of the paper with pastel, then paints over the pigment with a brush and turpentine. The color "melts," staining the paper, and when dried, becomes her underpainting.

PASTELCLOTH

Fay Moore's chosen surface is "pastelcloth," a material that she finds only at New York Central Art Sup-

ply in New York City. She says that pastelcloth is a non-woven fabric of synthetic fibers backed with a coating of fiberglass for additional strength. "This surface holds the pastel firmly, a bit like velour or velvet, but without that mushy look. It absorbs an underpainting or stain much like paper, but it doesn't buckle when wet."

Moore says some artists attach pastelcloth to stretchers like canvas. She is concerned that such a flexible surface could bounce the pastel off, so instead, she glues the pastelcloth to plywood or acid-free foam boards with acrylic gel medium.

There is also a pastel canvas made by Fredrix and this can be attached to a board to provide a strong, workable surface. Other fabrics can be used, but when you try new materials, whenever possible, they should be colorfast and acid free so that they don't discolor or disintegrate over time.

These three still lifes by Richard Pionk show how the type of surface can affect the finished image. In Bittersweet and Apples *on Canson paper, the color has an overall smoothness to it and the values tend to stay in the middle tones.*

Working on a gessoed board for Reflection *Pionk was able to underpaint to get greater value contrast—notice the stronger shadow area. Also the board gives greater texture to the pastel strokes, creating a more interesting surface texture.*

In Grapes and Apple *he was able to get the greatest value contrast on sandpaper; the luminous grapes seem to bounce off the bottle. Because sandpaper grabs the pastel and holds many layers of pigment, it enables the artist to build up intense color that rivals the finest oil paintings.*

Richard Pionk, *Bittersweet and Apples,* Canson paper, 19″×24″

Richard Pionk, *Reflection,* gessoed board, 16″×20″

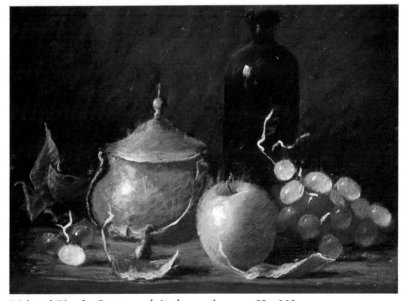

Richard Pionk, *Grapes and Apple,* sandpaper, 9″×11″

25

PASTEL BOARDS

More and more artists are applying pastels to various kinds of boards. Canson paper is now also available attached to mat board so you have all the advantages of a paper surface along with the support of a four-ply board.

Some artists simply gesso over mat board or Masonite for a stiff painting surface. By applying the gesso in layers of straight brush-strokes, alternating the direction of the strokes with each layer, you can build up a texture. This priming is important when you are under-painting, especially with oil or oil solvents that might damage raw mat board.

Some pastel artists prefer to texture their boards with a rough, sandy surface for several reasons. Barbara Hails feels that working on a sanded surface offers painting options not available with commercial boards. She says, "You need not worry about filling the 'tooth' of the surface. The gritty surface grips up to eight overlapping layers of color. Errors are unheard of. A swipe with a bristle brush takes you right back to the bare board. And because the board is subjected to moisture in its preparation stages, it even allows you to introduce wet media during your creative process if you wish, as long as you allow the board to dry flat.

"Commercially available sanded surfaces are loaded with acid and therefore impermanent. To achieve a conservation quality board with a flawlessly smooth surface I've developed the following formula and procedure."

Preparing a Sanded Surface Board

Materials:

2- or 4-ply 100% rag museum board
[recommended: Rising or "Crescent" four-ply board]
4 parts Liquitex acrylic gel medium
2 parts grit*
1 part water
optional: acrylic color to tone the board

(*various grits include:
200 mesh flint, pumice, marbledust, carborundum)

PREPARATION

1. Dampen the first side of the museum board with a wide brush and clean water. A dry board will soak up all the moisture in the sanding medium, making it impossible to apply smoothly.

2. While the board is very damp, use a 2-inch-wide brush to apply a thin coat of sanding mixture over the entire board. Coat the whole board three or four times, each time perpendicular to the previous brushing. The final brushing should just barely touch the surface, feathering lightly. Clean your brush immediately with soap and water. Place the board on a clean, flat support to dry. It will buckle and curl as it dries.

3. When the sanded surface is dry, the board will be warped. To flatten it, turn the board to the back side. Dampen it as in Step 1 with a brush and clean water. Use some weights to hold the board flat until the board softens from the water application and the tension relaxes.

4. Mix one part acrylic gesso with one part water in a reseal-able wide-mouthed container. With a wet 2-inch brush, apply an even, thin coat of the gesso and water mixture to the board. Place the board on a clean, flat support to dry. Clean your brush with soap and water.

5. When dry, cut the sanded boards to any workable size with a mat knife and straightedge. The boards may be stacked without harm, but should be stored flat. They are extremely durable and will take the application of water or oil media as long as they are allowed to dry on a flat surface.

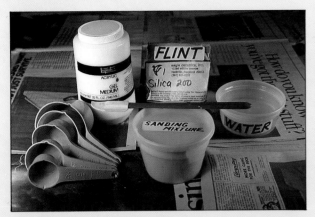

Assemble your material and cover a large, flat area with newspaper or plastic.

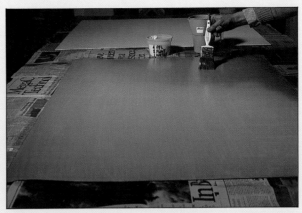

After dampening the board with clear water, brush on the sanding mixture in three or four coats.

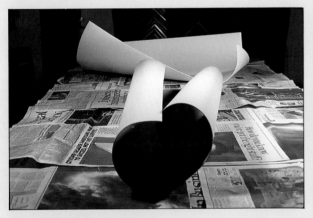

The board will curl as it dries.

Any heavy object can be used as a weight to flatten your board.

Apply an acrylic gesso mixture to the back of the board.

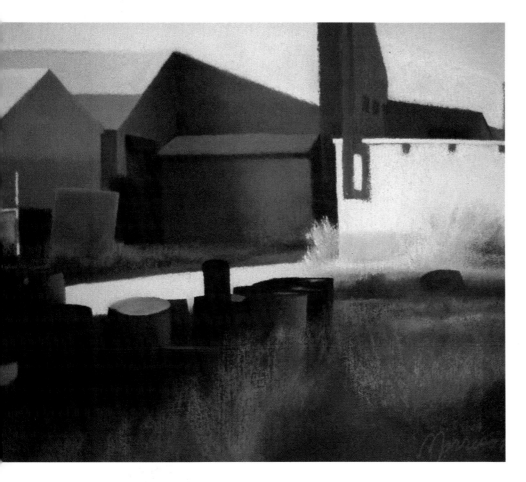

Mary Morrison, *The Yard*, 28½″ × 36″

For Morrison, the painting process is one of exploring composition. Although she lays down the basic design in her underpainting, she often changes the shapes and values several times before finishing a piece. What makes this working and reworking possible is that she sprays each layer of color with fixative as she goes along. This keeps the surface receptive to new layers of soft pastel so she can alter or completely eradicate earlier passages.

FIXATIVE

Although used primarily for preservation, spray fixative can also be a useful tool during the painting process. By spraying in between layers of pastel, you can maintain a workable surface and keep your successive strokes looking fresh and spontaneous.

The use of fixative to finish a pastel painting is the source of much controversy, especially between artists and dealers. Dealers want the surface of a painting to be absolutely clean and permanent. They would like to be able to run their finger across the pastel painting and not lift up any pastel dust. In order to achieve this state, an artist would have to spray an incredible amount of fixative on each piece. Not only would the spray make the surface permanent, but that much fixative would darken the colors and deaden the surface.

Artists, on the other hand, would like to leave the pastel in its pure state with no fixative whatsoever, but most recognize that this is impossible. Besides the pastel falling inside the frame and dirtying the mat, static electricity pulls the pigment off the paper and onto the glass or Plexiglas.

The solution for many artists is to spray heavily with fixative during the process of painting and lightly, if at all, when the painting is finished. I use a commercial fixative, Krylon or Blair, while I am working and use several very light coats on the finished piece. I use long, slow movements of my arm to make sure that the fixative goes on evenly. Single, heavy coats of fixative tend to leave a plastic-looking finish on the piece. It is also helpful to frame the painting with a spacer between the pastel and the mat, so any loose pigment will fall behind the mat.

To minimize the need for fixative, many artists try to remove excess pastel dust from the surface by tapping or shaking the board, sometimes quite vehemently. Tony Ortega, who works on paper, suggests holding down two corners of the paper and then blowing it with a hair dryer against the edge. This creates a strong vibration that removes excess pastel. A dust mask should be worn during this procedure.

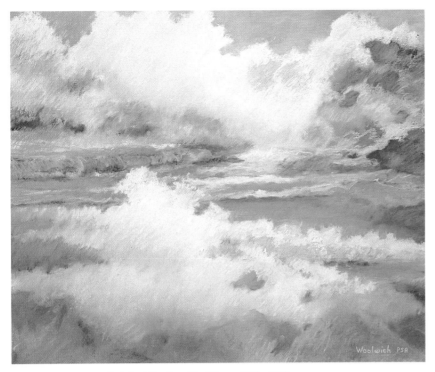

Madlyn-Ann Woolwich, *The Double Wave*, 22" × 28"

The first steps for Woolwich are to carefully develop the composition, values, and colors with charcoal, acrylic, and hard pastel. To this layer she applies fixative before going on to develop the final stage with soft pastel. When she considers her work finished, she hits the back of the board to get rid of any loose pastel, and then applies another coat of fixative.

Robert Frank describes his studio: "The easel and drawing board are placed beside a large 10-foot window that faces north. The easel is sturdy and easily adjustable. I keep a vacuum sweeper with a hose and nozzle behind my easel to keep the holding tray clean of pastel dust."

SAFETY

A word about safety in the studio. Pastel can be a very dangerous medium if not handled with care. The biggest problem is the dust, which can be poisonous. Working with the painting in an upright position minimizes dust in the air by allowing extra pastel dust to fall from the surface. In addition, wear a dust mask while painting.

Deborah Deichler says, "Pastel can be murder on my lungs. I actually get a 'cold' if I'm not really careful about not inhaling the fine dust. I use a very good air filter machine. Its disposable filter is completely clogged after one pastel painting. I rarely blow hard on a pastel in progress to cut down on white lung/black lung—but once in a while I do and the filter is right next to the picture turned on high!

"I spread out a shelf of aluminum foil that surrounds the bottom of the picture, sitting on the easel shelf. This catches an incredible amount of pastel dust and can be carefully scrunched up into a ball and disposed of." A trough of paper will serve the same purpose as Deichler's aluminum foil.

Be very careful of colors that contain toxic chemicals, like cadmium, especially if you are blending with your fingers. You will find a list of some of the toxic substances found in pastels in Appendix A of this book.

Commercial fixative is also dangerous and should only be used in a well-ventilated location; I usually take my paintings outside to spray them. A gas filter can also be worn over the face to protect you from noxious spray.

From Hard to Soft Pastels

MADLYN-ANN WOOLWICH

Madlyn-Ann Woolwich is a New Jersey artist who is proud of being a Master Pastellist of the Pastel Society of America. Through the years she has worked with pastel, she has developed a technique that takes full advantage of the different types of pastels, from hard to soft. Her goal is attaining the maximum luminescence in her paintings.

Woolwich chooses a subject in nature—landscape, seascape, or floral. She begins every painting with a group of studies, value studies in pencil, and 5 × 7-inch color studies in pastel or watercolor. She also shoots backup photographs to capture details of light and weather conditions that change too quickly to sketch.

She creates her pastel paintings on a surface of illustration or mat board coated with acrylic, gesso, and ground pumice. This gives her a strong, biting surface that will hold the six layers of pigment she uses to complete every painting.

Woolwich works her paintings from dark to light, using her own handmade pastels for the deepest colors. In order to create bright luminosity, she says, a painting must contain "strong and juicy darks. Contrast is the factor that energizes composition, and the distribution of the sparkling lights ties the tapestry of the landscape together. A successful landscape has a life of its own. All the elements combine to permit an emotional explosion of color, drawing, and mood."

Step 1: *Using the sketches and reference photos, she sketched a composition in soft charcoal pencil, paying particular attention to negative shapes. When she felt the drawing was adequate, she sprayed it with Morilla workable fixative. Excess charcoal was brushed off to keep a clean surface.*

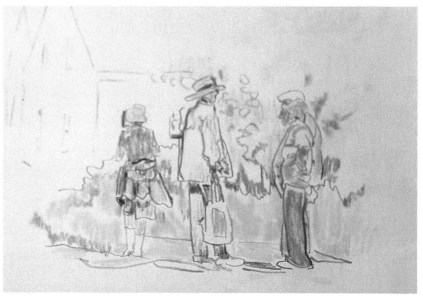

As usual, Woolwich began this painting by making color sketches and photographs of the scene and the people to be included.

She prepared a sheet of sanded board using a mixture of gesso, water, and pumice on acid-free museum board. A mixture of raw umber, Hooker's green, and yellow ochre acrylic paint was added to the gesso mixture.

30

Step 2: *Working on an easel, she drew over the charcoal drawing with blue acrylic paint using a no. 6 Robert Simmons rigger brush.*

Step 3: *Next came an acrylic underpainting, which generally approximates the value and colors of the subject. Some parts, such as the sky, were underpainted a different color than the subject for a more interesting final color. Whites are usually underpainted yellow or orange to convey the warmth of sunshine. She painted the large, dark spaces with dark green, cobalt blue, and purple.*

Step 4: *The composition was now worked with NuPastel and Conté hard pastels. She applied this color in loose, unblended strokes, using the direction and type of stroke to begin to indicate the natural textures of her subject. At this stage she stuck mainly to medium and dark values, with only a few lights for comparison. After this layer, she lightly sprayed with fixative again.*

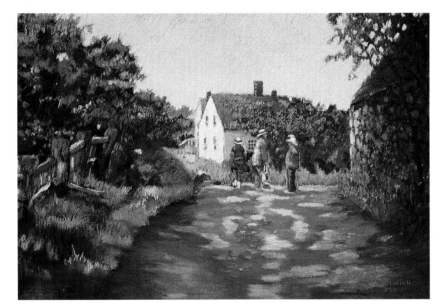

Step 5: *Next came the softer Rembrandt pastel. With the thick strokes of soft pastel she began to adjust to final color and value. She worked all over the painting, repeating colors in different places. She does not rub pastels usually, but this particular one needed a bit of blending in the light/shadow patterns. This layer was sprayed lightly with fixative.*

Madlyn-Ann Woolwich, *Midmorning on Monhegan Island,* 19″ × 29″

Step 6: *The last strokes are with Rowney, Sennelier, and Schmincke, the softest and heaviest yet. Woolwich says, "The rich, crumbly soft pastels are almost pure pigment, and the colors glow as you use them."*

In this final stage she refines the drawing and reworks the value of the sky. "Lastly comes the best part of the pastel—dashing in the juicy lights on the people, roof, grass, fence, and path. My intent is to keep the focus on the three people. Splashing the light around them tends to keep the focus there."

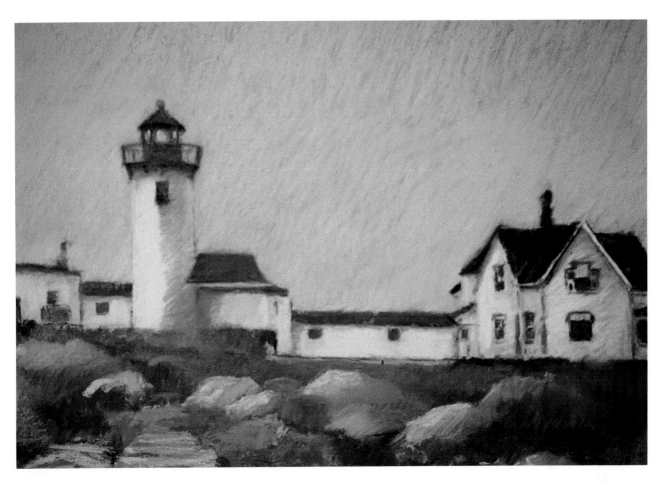

Madlyn-Ann Woolwich, *East Point Lighthouse*, 21″ × 28″

Although she underpaints with acrylic and builds up early colors with hard pastel, the finished surface of Woolwich's painting shows the rich, heavy strokes possible only with very soft pastel on a sanded board. These quick, bold strokes energize even this stable, architectural subject.

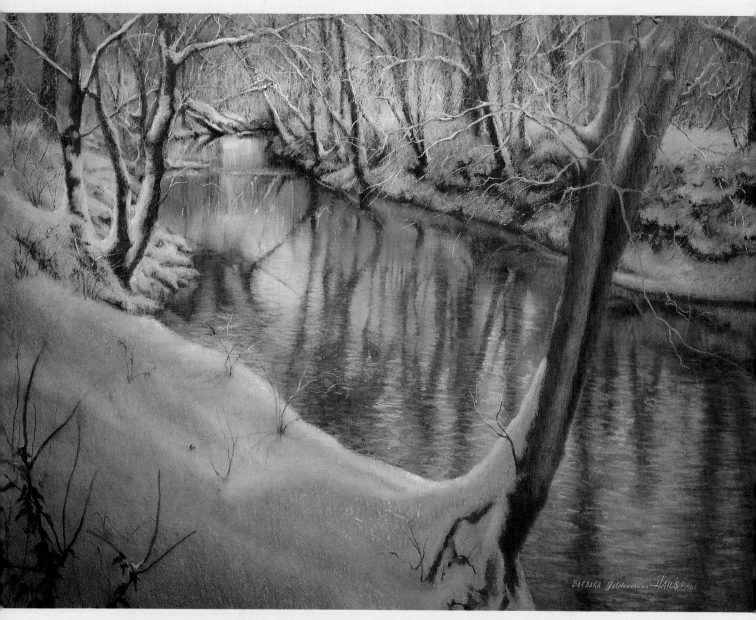

Barbara Geldermann Hails, *Solitude,* 32″×40″

UNDERPAINTING
Putting Down a Base

Many artists begin their pastel paintings with an underpainting in another medium. Before they apply their first stroke of pastel, they cover the paper or board with watercolor, acrylic, or oil. They let this first layer of color dry and then they begin with pastel.

The underpainting can be as simple as a solid wash of one color or as complex as a finished painting. Its purpose is to provide tone, delineation, value, or local color.

TONE

The tone can be one solid color or separate areas of different colors keyed to the color that will be placed later. The initial color of the underpainting will have an effect on whatever colors are added. Say you paint a cool blue coat onto the paper. Then you cover that blue with a layer of orange. If the orange is applied in light strokes or blended to a thin, transparent layer, the blue will show through the orange, making it a grayed or cooler orange. If the orange is applied in broken strokes of solid orange, the complementary blue will show between the strokes of orange so the colors seem to vibrate. At a distance, the eye will blend the col-

ors together, but up close the colors will have the sparkle of adjacent complementaries.

If you paint the same color under the pastel, such as a blue underpainting topped by strokes of blue pastel, the color will appear much more intense than just a single layer of blue pastel.

One of the difficulties of working on white paper, especially a roughly textured paper, is that the little white spots that are untouched by pastel can be very distracting in the final painting. An initial wash will make these raw spots much more harmonious.

DELINEATION

Many artists like to place the exact contours and details of a composition in an underpainting. This frees them to devote the next layers of the piece to the best qualities of soft pastel—color, value, and texture. Many very spontaneous-looking pastel paintings are actually the result of a very controlled underpainting. Once the basic forms are all in place, the artist can be more expressive with his or her stroke, knowing that the basic structure is sound.

ESTABLISHING VALUE

By painting a wash of color onto a white paper or board, the artist establishes a basic tone or middle value to place subsequent values against. One of the advantages of pastel is that it can be worked dark to light, light to dark or back and forth. Many artists find that starting with a middle value makes it easier to determine the relationships of lights and darks.

Hails begins her pastel paintings with a precise drawing. She then overlays an acrylic underpainting (right), being careful to maintain the integrity of the drawing. With the acrylic she indicates value and large masses of color. In her finished work (left) she sticks closely to the composition she established in the underpainting.

Many artists build their pastel paintings as mosaics of broken strokes of many colors. It is often easier to establish value using one single color painted onto the paper before beginning to work with many colors. The first color serves as a guide for judging the value of all subsequent strokes.

Establishing dark values can be difficult with pastel. Often the dark colors you need are not available and using black can deaden a piece. One solution is to wash in the darks first with a different medium.

LOCAL COLOR

Working out the local color, or actual color, can also be done in the underpainting, putting blue where the blue sky will be or red where an apple will be. By laying down the colors first in paint and then going over them with the same or similar colors, it is possible to develop very intense areas of color.

THE BEST MEDIUM

What is the best medium to use for underpainting? It depends on the surface and the preference of the artist. Watermedia work very well on heavy watercolor papers and mat boards with no special treatment. With lighter papers, the paper should be stretched first or coated with gesso if possible. This will eliminate buckling.

Oil does not cause paper to buckle, but the oil in the paint can stain the paper and there is some question about the effect of oil paints and solvents on the permanence of paper. For maximum durability I suggest using oil, turpentine, or other solvents only on surfaces that have been primed.

In this first stage Fay Moore uses loose washes of watercolor and basic lines to mark the major shapes of the composition.

Moore further develops the composition with more definite shapes in watercolor. Now the basic composition is laid out and the darkest values are indicated.

Some artists use oil washes or washes of turpentine and pastel on commercial sandpaper because water can damage the sanded surface. Experiment to see what works best for you.

In most cases it is good to apply the underpainting in thin washes so thick strokes of paint don't impair the texture of your surface. How much the underpainting will show through depends on the intensity of the underpainted color, the pressure and density of your pastel strokes, and the hardness of the pastels. Rarely will hard pastels completely hide an underpainting. You can build up several layers of hard pastel and usually the underpainting will still show through.

To keep the underpainting visible when you use soft pastels, which create more opaque color, you must use very light strokes, thin the pastel by blending, or use loose strokes that show the underpainting between the pastel marks.

One advantage of working out problems in an underpainting is that it eliminates at least one layer of pastel, an important consideration, since most surfaces will hold only a few layers. Also, mistakes in the underpainting can be easily covered with soft pastel.

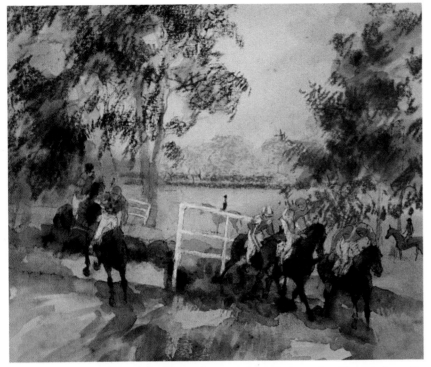

Here she begins to add pastel, refining shapes and developing color. She uses Sennelier and Schmincke pastels with some Rembrandt sticks for harder lines.

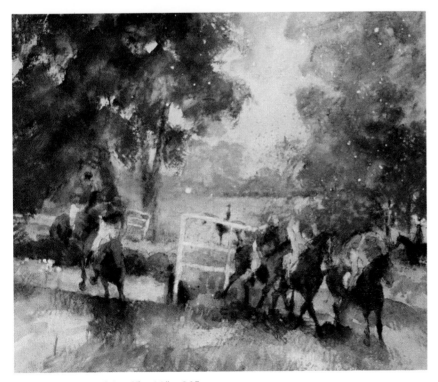

In the final painting, some of the watercolor shapes are still visible, especially in the darker values. Moore likes a rich variety of textures in the finished piece, so she might add more washes and splatters of watercolor even after she has begun to work with pastel.

Fay Moore, *Hard Scuffle*, 18″ × 20″

Sally Strand uses a very loose watercolor underpainting to tone her white watercolor paper. Using loose strokes with a large brush, she generally indicates the colors and values that will comprise the finished painting.

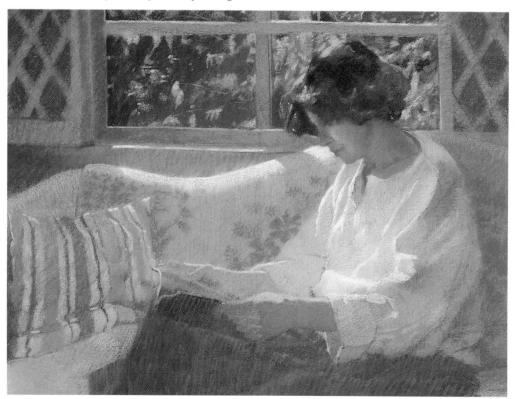

Sally Strand, *Rosemarie Reading,* 24" × 30"

In this piece she builds thickly with soft pastel so none of the watercolor shows through in the final image.

In this underpainting, Strand uses the watercolor to establish the value relationships of her composition. She paints a rich brown background in contrast with the woman's white blouse.

Sally Strand, *Tying Up Hair*, 13″ × 15″

In the final painting we see that she has covered over most of the original color in the figure, but she allows the brown underpainting to provide the basic color for the background.

Color for Emotional Impact

Step 1: *"This pastel painting was on ⅛-inch Masonite, primed with three layers of acrylic gesso. I blocked in the big shapes with acrylic paint that would affect the color throughout. I had only two concerns at this stage: 1) using values of paint that would help me visualize the composition and 2) using a warm color in the background, against which I could play the cooler colors of the finished piece. I coated the whole surface with a mixture of acrylic gel medium and pumice."*

DOUG DAWSON

"I choose to do a painting because I have an emotional, gut response to the subject. Probably my desire to paint has to do with my trying to understand that feeling in myself. Painting is a way to explore my own emotional response to the world around me," says Doug Dawson.

In order to concentrate on his main concern, the emotional expression of the piece, Dawson has developed a simplified approach to painting.

He uses a bold underpainting to establish both shape and value, as described in Chapters 7 and 10. Then, with basically three sticks of color, a dark, medium, and light, he clarifies the large shapes of the composition. Gradually he subdivides the shapes with new colors until he reaches his smallest shapes or details.

He limits himself to a small number of colors for each painting and he is careful to repeat each color within the piece. This repetition promotes color unity.

Working on sanded board he is able to apply heavy strokes of pastel for dense color and maximum contrast. This rich color is essential to his highly expressive images.

Step 2: *"My procedure was to block in the big shapes and break them down into smaller shapes. In this instance, the shapes painted in acrylic represent the first step in that process. I barely suggest important details like facial features and windows and I try out spots of future color.*

"Establishing the background color and value was an important step. Doing so allowed me to determine with confidence the colors I would use in the girl's face. We always see colors in relationship to the colors next to them. If I were to completely finish the girl's face and then paint the background, likely as not the new background color would adversely affect the colors I had used in her face."

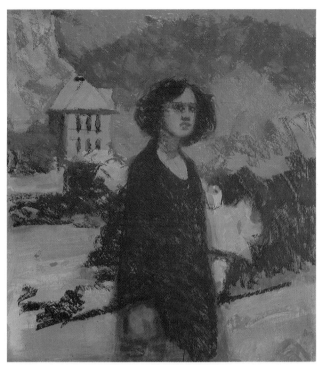

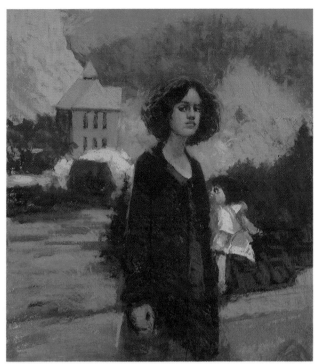

Step 3: *"I blocked in more background. At this point I was concerned about getting the value relationships between the big shapes as correct as possible. At the same time I was introducing the new colors I would use in large areas."*

Step 4: *"It is often recommended, and I agree, that you should work on all the different parts of the painting and not dwell on any one, but in this case I departed from that. The success of the piece was going to rest on the expressive character of the face and how it worked against the other colors in the painting."*

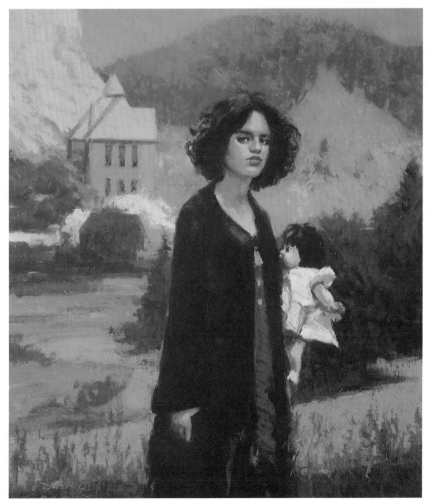

Doug Dawson, *Elizabeth's Daughter,* 37″ × 33″

Step 5: *"This is the most difficult stage to explain to students. How do you finish a piece? In this last stage I broke all the shapes down into their final size, the size of which was determined by Elizabeth's face. I kept all the other shapes as large or larger than the smallest shapes in her face. This helps draw your eye to her, making her the center of interest. The effect was almost as if she was all that was in focus in the painting. Points of the pink underpainting show through to help unify the painting.*

"I previously held off using my lightest values. Now I introduced them and I searched the surface of the painting for any areas that seemed inconsistent in style with the rest of the piece."

41

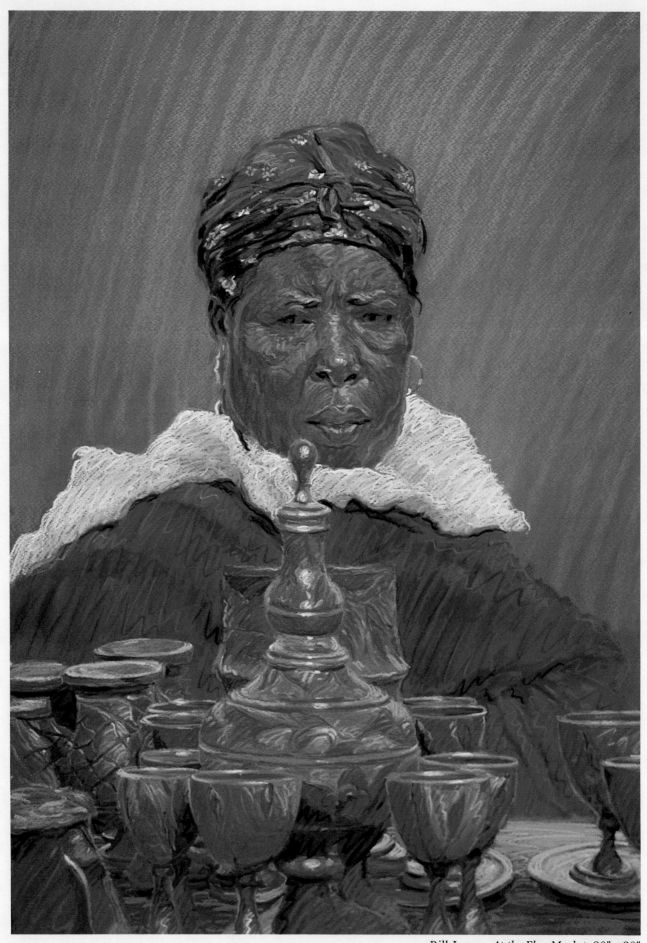

Bill James, *At the Flea Market*, 20″×28″

STROKES
The Building Blocks of Color

In pastel, the individual strokes of color are used for more than just to cover the surface. They can also provide texture, show depth and volume, outline contours, and establish detail.

Like brushstrokes, each pastel stroke has its own character. It can be short, long, fat, thin, curved, or straight. It can be unobtrusive or dynamic, predictable or unexpected. It can be a line, a dot, a dash, or a squiggle.

It is important for a pastellist to develop a repertoire of strokes so he or she can make a deliberate decision about the type of stroke to be used. By applying your marks of pastel in an imaginative, but deliberate way, you can best develop your own distinctive pastel style.

I always suggest that students practice making different kinds of marks with pastel. Make rows of lines—short, long, thick, thin. Make rows of dots. Vary the strokes with a new size or shape of pastel stick or pencil, the way it is held, the amount of pressure used. Then look at all these different marks and think about where they would be most effective in your paintings.

(Above left) This is an example of building a strong area of color with pointillism. See how this becomes a rich green as more layers of green, yellow, and blue are added. The eye will blend all the strokes of color into one solid shape.

(Above right) These are various types of crosshatching. By leaving the strokes unblended, you create an interesting surface texture.

(Left) These strokes are all from one pastel stick. I encourage beginning pastellists to play and see how many different kinds of strokes they can develop. Become familiar with the potential of your materials before you begin; then you won't have to struggle for a new stroke in the middle of a painting.

43

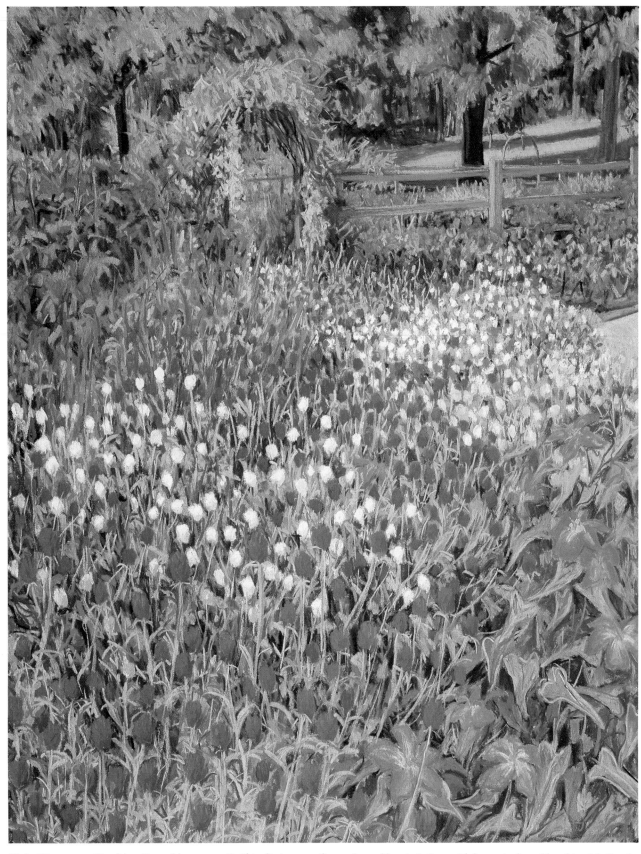

Elsie Dinsmore Popkin, *Reynolda Gardens—Globe Amaranth and Abelmoschus*, 39¼″×30″

Popkin first covers the surface of her painting with loose strokes of hard pastel. Gradually, the pastels become softer and the strokes become more precise so that in the top layer of the painting, each bit of color fits together to create a solid expanse resembling a mosaic of color.

COVERING LARGE AREAS

You can cover large areas with solid color by drawing wide strokes with the side of your pastel stick or by blending thin strokes. You can also cover areas with broken color and often that creates a much more interesting effect, creating not just flat color, but also an interesting surface texture as well.

Suppose you want a green area. Pick out several sticks of green, yellow, and blue. Make a layer of small strokes of green over that area. Now add a layer of small strokes of yellow. Now a layer of blue; then another of green and so on. Do not blend the strokes together. Just keep adding more layers until the color is as dense as you want.

Another technique is crosshatching, which involves layering lines. There are basically three kinds of crosshatching. The first sets down rows of linear strokes all in the same direction. Cover those with more strokes in the same direction and continue the process until you have the intensity of color you want. (This technique is also called feathering or hatching.)

Second is the most traditional type of crosshatching. Draw many straight strokes going in the same direction (for example, vertical). Next cover those with parallel strokes in another direction (horizontal). Add more lines in another direction (diagonal) and so on. This creates a geometric, woven-looking pattern.

Third is drawing layers of random or scribbled strokes. Cover the area with one layer of random strokes. Add another layer and so on. This looser type of crosshatching will give your strokes a more organic appearance.

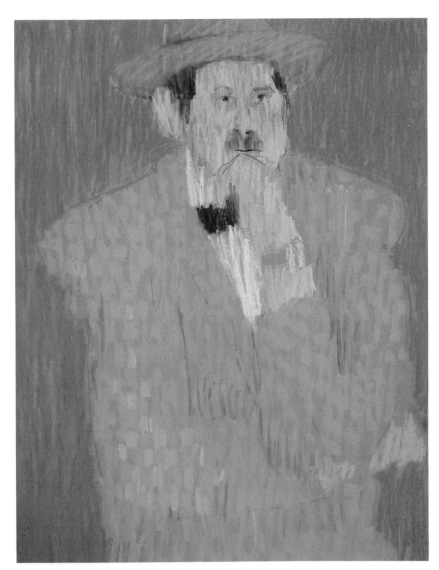

Carole Katchen, *The Art Historian,* 25″ × 19″

This is a good example of combining a variety of strokes in one painting. The face, background, and shadows are executed in linear strokes. The jacket is distinguished by square strokes to give a checked effect. The hat is crosshatched with vertical and diagonal strokes that give it a rounded feel. One danger of creating patterns with strokes is that the pattern can detract from the overall design of the painting. I dealt with that problem here by using several different types of strokes so one pattern would not dominate.

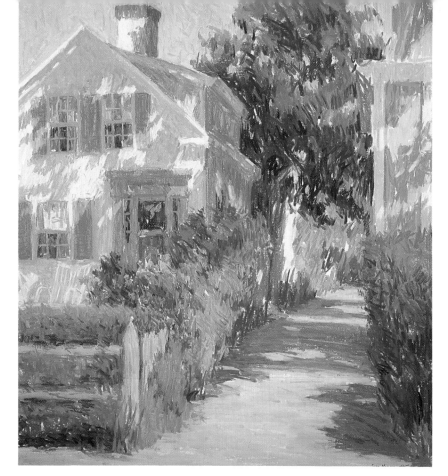

Simie Maryles, *Morning Patterns, Asheton House*, 21″ × 19″

Barbara Geldermann Hails, *Boardwalk through the Dunes*, 32″ × 40″

In both these paintings the artists have used strokes of greens, golds, and pinks to show grasses and flowers. However, the types of strokes give the foliage in each piece a very different character. Maryles has used short, choppy strokes for the greenery as well as the buildings, so the total painting has a solid, unified look. Hails painted the grasses with long, feathery strokes that make them look graceful and set them apart from the flat strokes of the background.

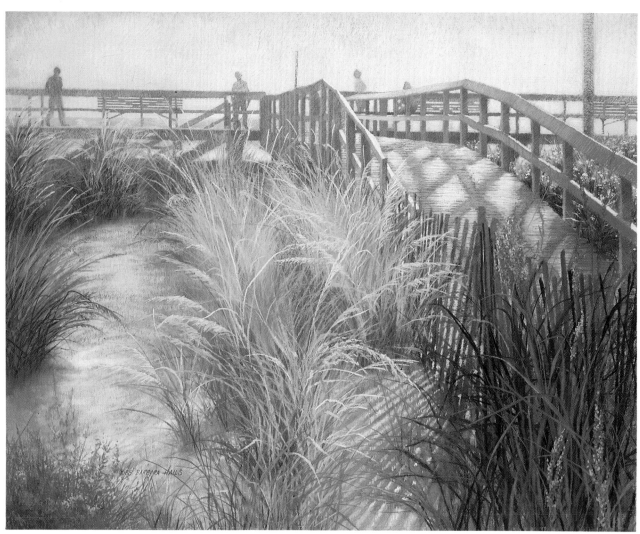

THE SENSE OF THE PAINTING

It is very important to be aware of how the nature of your strokes affects the sense of the painting. Here are some suggestions about pastel strokes:

• If you are trying to paint a round, three-dimensional form, rounded strokes can reinforce the illusion of roundness, while straight strokes can flatten the image out.

• If you want to create a sense of depth in your paintings, use strong, definite strokes in the foreground and softer, less defined strokes in the distance. This will enhance the illusion of space.

• Areas of very bright light or very deep shadow—those lighting situations where detail is not easily seen—will be more believable with less obvious strokes.

• To make a focal point more powerful, render it in strong, definite strokes and surround it with softer strokes.

• Strokes with a decorative feel (elaborately curved strokes, geometric patterns of strokes and the like) will tend to make an area or even a whole painting look decorative when used indiscriminately. This is a problem if your goal is realism.

• If all your strokes are the same length or direction, they can make your painting look mechanical.

• If every single stroke is different from all the others, it can create a sense of chaos. For the most interesting surface texture that does not detract from your subject, vary your strokes in a limited way, repeating each type enough to provide a feel of consistency.

• Finally, if the strokes themselves ever become the most dominant element in the painting, they will detract from the impact of the painting as a whole. Because of the rich expressiveness of pastels, especially soft pastels, the strokes themselves can be absorbing. It is important to keep in mind, though, how the character of the stroke is going to affect the finished art. Never become so involved with the individual strokes that you lose touch with the total painting.

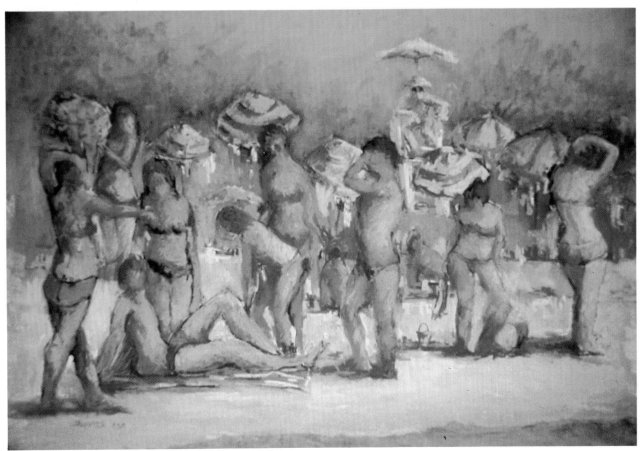

Sidney Hermel, *Horseshoe Bay, Bermuda,* 24" × 30"

Hermel worked here on sanded board. This toothy surface grabs the pastel and tends to make the strokes look more integrated than they would on a smoother surface.

Building Color with Lines

BILL JAMES

Many artists use lines for the initial drawing of their paintings, but Bill James makes line part of the painting process itself. He says, "My technique is different from other pastel artists in that I do not rub to create form or depth, but rather use a series of color strokes to form the elements being drawn."

This technique of laying down and leaving individual strokes of color is vital to James's practice of bouncing warm colors against cool colors. Rather than blending strokes to achieve grayed colors, he allows the colors to vibrate against each other. From a distance, the eye blends the separate strokes, but up close the painting dances with vitality.

In this demonstration you can see James's imaginative use of color. Even when outlining objects, he uses strong, bright colors that will add sparkle to the finished piece. For example, the violet and pink first used to outline the large vase are still visible in the finished painting. In James's work no stroke of color is a "throwaway." Every single line helps to build the final image.

Step 1: *James says, "I begin drawing in the main elements using colors complementary to the color each element will finally be rendered in."*

Step 2: *"I work in the background so I can get a better idea of how the subject matter is progressing. Before doing the final rendering on the vases, I draw in the flowered pattern and also indicate the shadow and color separations on the glasses."*

48

Step 3: *"I start working in the color on the vases. Notice that because the colors of the vases themselves are on the warm side, I did the initial drawing in complementary blue and green colors. I also start working on the color of the table."*

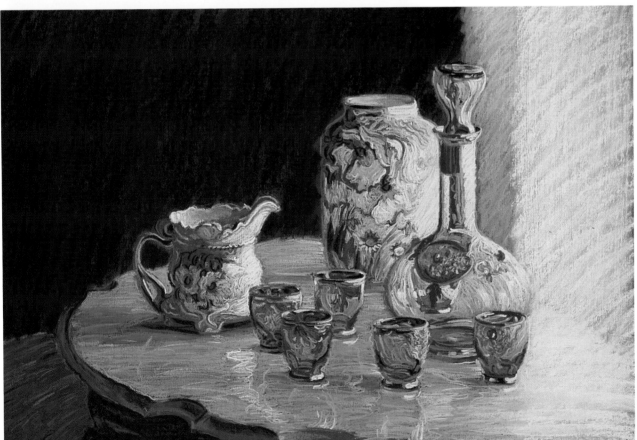

Bill James, *Still Life in Blue and Gold,*
18″ × 27″

Step 4: *"I continue rendering the table and start adding color to the glasses. The rug in the lower left corner is worked in and the table is completed. Final touches are added to all the elements in the painting. More complementary color is added to make the subject matter really jump out at you."*

Layers and Layers of Strokes

This is the photo study that Diana Randolph used as a reference in developing the painting. The photo is a guide to shape, value, and texture. In color she strives for the intensity of the actual scene.

DIANA RANDOLPH

Unlike Bill James, who lays down only one layer of strokes, Diana Randolph builds her paintings slowly, layer upon layer. After the underpainting, she does not blend the pastel, but uses a profusion of strokes to create a solid image.

Inspired by the richly wooded countryside of northern Wisconsin, she has developed her own way of seeing and re-creating scenes in nature.

Randolph begins her paintings by blocking in areas of color with wide strokes of NuPastel, which she then blends with turpentine or another solvent. Then she begins to build up the many layers of strokes that comprise her paintings.

She uses a loose type of cross-hatching allowing enough space between the strokes for the underpainting to show through. The result of this process of building up loose layers of strokes is a solid-looking painting with a vital surface texture. The color is enriched by glimpses of all the previous layers of color showing through.

Step 1: *She begins by dividing the composition into large shapes of color. She paints on sandpaper with broad strokes of the flat sides of NuPastels. She is more concerned here with value than color.*

Step 2: *She dips a brush in odorless paint thinner and paints over each color, creating a smooth wash that stains the paper. She wipes the brush with a paper towel between each color.*

Step 3: *After the wash has dried, she begins to reinforce the colors with loose, linear strokes of NuPastel. She intensifies the darkest areas with layers of additional colors. She wants strong darks here because they will be softened with subsequent layers of color.*

Step 4: *She now concentrates on middle tones. She adds strokes of middle greens over much of the surface. By overlapping areas of color, she is able to build a total color harmony.*

51

Step 5: *Still working with NuPastels, she concentrates on lighter values. Notice that she mixes strokes of blue, yellow, and green for an overall feeling of green, getting a more lively surface than if she painted on a solid green. She uses a loose texture to get the "feathery texture of grasses."*

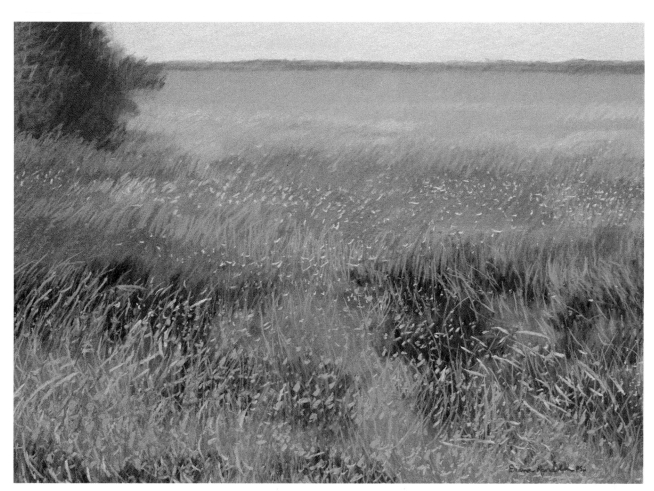

Diana Randolph, *Field of Gold,* 16″ × 22″

Step 6: *In the last stages she turns to softer Rembrandt and Sennelier pastels. She focuses on the wildflowers and the texture of the grasses, using crisp strokes of soft pastel to show up over the other layers of color. She makes the strokes in the foreground more specific than those in the background to enhance the sense of depth.*

Detail: *This close-up shows the tremendous variety of strokes and colors that blend together to make the total image.*

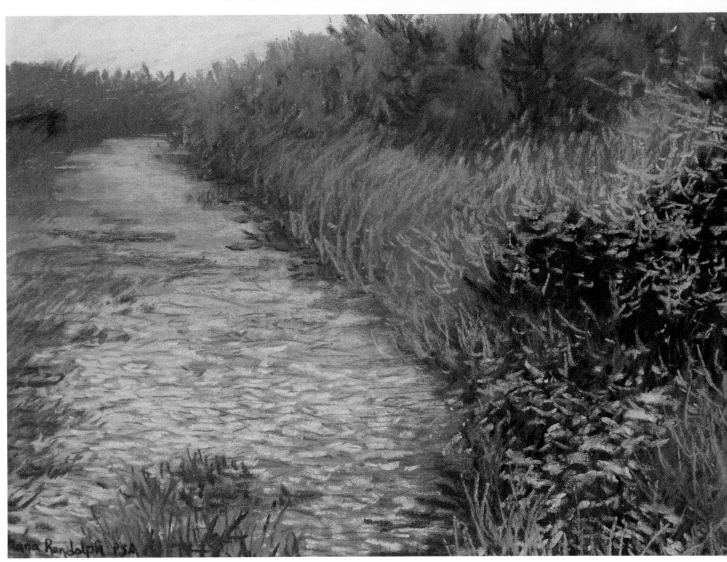

Diana Randolph, *Sunlit Walk,*
12″ × 16″

This is a good example of many different types of strokes in one painting. Notice how each kind of stroke serves its own purpose: crisp, little strokes for flowers; thin, linear strokes for grasses; thicker strokes for tree branches; horizontal strokes to establish the flat plane of the path; and loose, indistinct strokes for the distant sky.

53

Richard Pionk, *Mountain Laurel,* 19″ × 29″

BLENDING
The Smooth Finish

One of the unique properties of pastel is its ability to be blended. Because the pigment is dry, it is easily moved. Put down a stroke of color. Touch it with a finger, cloth, or brush and the shape of the stroke is transformed.

Smoothing the strokes together makes the colors flow into each other magically with no beginning and no end. However, blending must be used with discretion. It softens everything—lines, shapes, colors, and values—and too much softness can lead to dull, vacuous paintings.

TOOLS FOR BLENDING

Blending pastel strokes is simply a matter of rubbing the dry pastel pigment across or into the surface. It can be done with the fingers, a cloth, paper towel, brush, drawing stump, cotton swab, or another stick of pastel. Each tool takes off a different amount of pastel. You might work with great care to get exactly the color you want, then wipe it with a cloth and find that most of your color is gone.

For me, the most successful blending tool has been my fingers. For some reason, rubbing with the finger seems to push most of the pigment into the paper, lifting off just a small amount. Also I have more control with a finger than with any other tool.

Unfortunately, many pastel colors contain toxic chemicals that can be absorbed into the skin. I don't know that there is a totally satisfactory solution, but I take the following basic precautions: I try to avoid all colors that I know are toxic, such as cadmiums, and I wash my hands frequently while I am working.

When I want to remove more pigment from the surface, I use a cloth or paper towel for blending. Brushes also work, but they can also lift off more color, though soft brushes will remove less pigment than hard-bristle brushes. Drawing stumps and cotton swabs are good for small areas, but they take on the color that has been blended; so you have to be careful not to contaminate other colors.

You can also blend with subsequent strokes of pastel. Most effective is a medium to hard pastel used over a layer of soft pastel. The effect of blending can also be created with dense strokes of color, applied so closely together that they appear to be solid pigment.

These are all ways of blending dry pastel. It is also possible to blend pastel wet, using liquid as a vehicle for moving the pigment around. For instance, if you want to eliminate heavy strokes from an

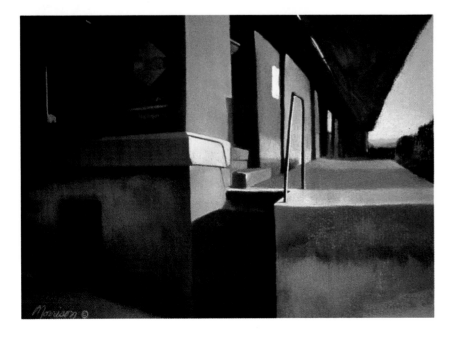

Mary Morrison, *Last Train,*
29½" × 40"

On the walls and platform in Morrison's painting there are many different colors, but the pigments seem to flow into each other without interruption. Morrison gets these blended surfaces by applying the softest pastel first, then painting over that with harder pastels, blending the lower layer. She uses a circular motion to keep individual strokes less distinct.

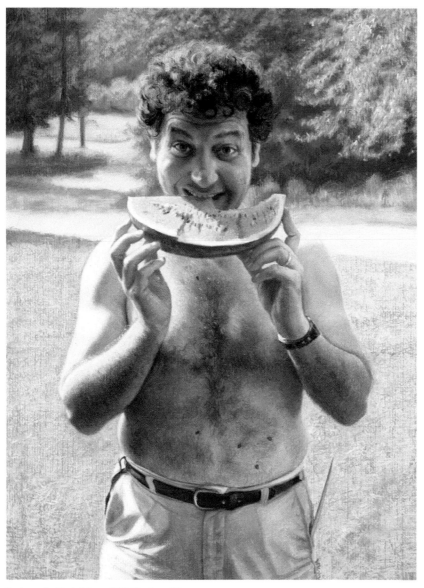

Deborah Deichler, *Bill Eating Water-melon,* 26″ × 19″

Blending is essential for Deichler to achieve the uninterrupted color of skin areas. Even going from shadows to high-lights the colors flow easily into each other. She gets this smoothness by blending with a small, soft watercolor brush or her finger.

area, you can "paint" over that section with water or a solvent such as turpentine. Wetting the pastels may darken the colors and it will definitely change the texture. Try different amounts of liquid and different types of brushstrokes to see what kinds of effects you can get. Applying water to paper may cause the paper to buckle, so it is best to use water with your pastels only on very heavy or primed paper or board. Wet blending is usually used for underpainting.

SPECIAL CONSIDERATIONS

If you know you are going to blend an area, you can make the job simpler by the type of strokes you apply. Soft pastels blend more easily than hard. For covering a large, smooth area, use wide strokes of the flat side of your chalk. The amount of pressure will also affect blending. Very light strokes can lift right off the paper; very heavy strokes can be so deeply imbedded in the paper that the pigment will hardly move.

Blending will always lift off some of the pigment, so the best way to achieve very intense colors is to apply many layers of blended strokes. Stroke on the pastel, rub it in, shake off the excess dust, then repeat the process until you get the desired color or value.

Fixative can be a useful tool in building up blended layers. Blend your pastel. Spray lightly with fixative. Add more color, blend, spray, and so on.

Some artists avoid blending because they say it muddies the color. This is not necessarily true. It depends on how you combine your colors. By blending strokes or layers of different blues, for example, you can achieve skies of a very rich, intense color.

Blending complementaries will always result in grayed colors, but these are important to include in a painting to provide a counterpoint to the dramatic pure colors. Blending any color with browns or black can deaden the original color, so be careful with these.

An important consideration is that blending removes surface texture as well as dramatic lines and edges. So you have to find other ways to give your blended paintings more punch—perhaps intensifying colors or value contrast or adding a few unblended strokes as accents.

Blending can be used over the entire painting surface to create a totally smooth painting or it can be used just in spots to contrast with bold individual strokes. Many effective paintings are achieved with no blending at all, but this unique pastel technique should be kept in mind as a valuable resource.

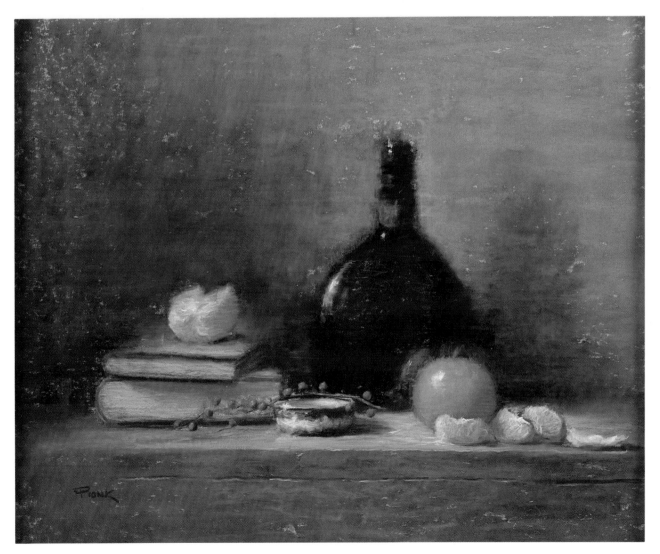

Richard Pionk, *Oranges and Books,* 13" × 18"

Richard Pionk's paintings are a combination of distinct and blended strokes. Sometimes he likes to leave individual strokes untouched, as in the orange segments and the blue bowl. He gets some smooth areas of color by painting wide strokes with the side of the pastel stick. In a few places he blends with his finger, as when a rounded object seems to merge into the background.

Diana Randolph blocks in her main areas of color with pastel.

With a flat bristle brush and paint thinner she blends the pigment. The pastel "melts" and becomes her underpainting.

Diana Randolph, *Dotted Meadow,* 16″ × 22″

In the final painting the blended under-painting shows through as vague tones and tiny slivers of color.

WHEN TO BLEND

When should you blend your pastel strokes?

• Whenever strong individual strokes or textures will detract from a passage of a painting, you can blend the pastel for a softer, gentler effect.

• When you want your color to have a smooth finish, blending will give you a smooth texture even on a roughly textured paper.

• When you want to create more realistic edges on objects or when you want to eliminate hard edges between colors, you can blend.

• When a color is too strong, overpowering the colors around it, you can soften the color by blending.

• When you want to show distance, you can blend the details and edges that are far away, leaving the nearer objects sharper. This will enhance the illusion of space.

• When you want realistic shadows, you can blend the shadow colors into a solid mass and let the edges bleed into the surrounding color.

• When you want soft, three-dimensional contours, as on a face or distant landscape, you can blend the colors so they flow into each other.

• When you want to give a realistic impression of a smooth surface, blending will enhance the effect.

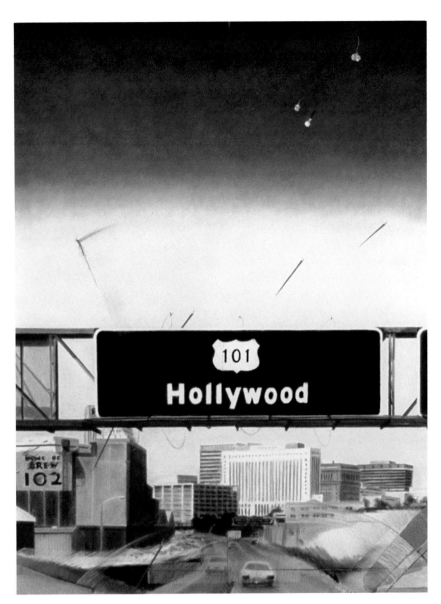

Christian Heckscher, *Hollywood 101,* 41″ × 31″

To express the "kinetic energy" this Belgian artist sees in Southern California he combines a precise style, with colors blended for a smooth, solid look, with contrasting accents of bold, colored bits of fabric, thread, or metal.

Painting with his Fingers

CHRISTIAN HECKSCHER

When Christian Heckscher moved from Belgium to Los Angeles, he was taken with the Southern California sky—big expanses of intense blue, that he had rarely seen in Europe. A major theme of his American paintings, the sky, needed a technique that would create smooth but intense expanses of color. He developed that technique by blending—rubbing successive layers of pastel strokes into the paper with his fingers.

In light areas like clouds, he may stop with one layer, but in darker areas he adds more layers of color. Blue may actually be painted with layers of blue, gray, blue-gray, and violet. In some sections he leaves untouched white paper, intensifying the bright areas even more with white pastel.

In finishing his paintings Heckscher combines the realism of his painting technique with collage abstraction. After the body of the painting is completed as a realistic, almost photographic image, the artist adds thread, paper, fabric, or metal and arbitrary lines and dots of pastel. He says that these unexpected accents better convey the kinetic energy that is Southern California.

Step 1: *Heckscher works with his paper flat to keep the pastel dust from contaminating the white paper. He begins by drawing the image with black Conté crayon. Then he develops one section at a time. Generally he starts with the top, completing that area before he moves on to the next. With smaller pieces of paper he covers up areas that will remain white, removing the protective paper only when he is ready to work that section. He sprays each finished area with fixative before he goes on to the next.*

Step 2: *Having finished the sky, he moves on to the sea. In order to get that intense blue on white paper, he applies many layers of blended color, with a circular motion.*

The triangular shapes along the right side are for abstract accents that he adds to his otherwise realistic painting. The white spot at the top will be used for a collaged accent.

Notice the chalks and eraser on a piece of paper at the bottom. Because he works with the paper flat, he must protect the painting surface as he works. He rests his arm on a piece of glass so he doesn't smear the work.

Step 3: *Next he puts in the buildings and foliage of the shoreline. In each area he works from light to dark. He blends the colors with his fingers and adds the sharp details on top only when the main shapes in the section are done. For sharp edges he blends his colors against a straightedge or paper cut-out.*

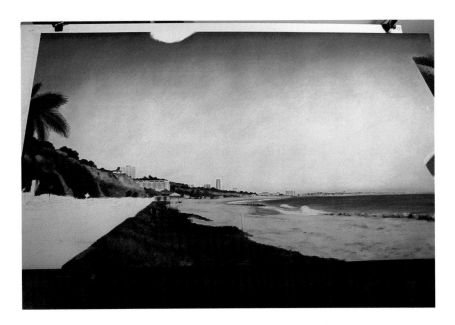

Step 4: *At this stage he adds the sand, the beach details, and the grass in the foreground.*

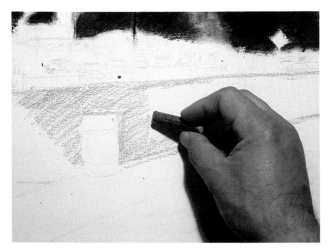 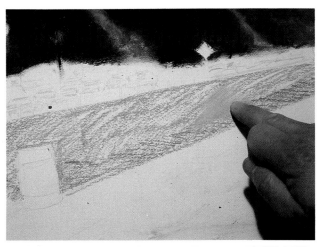

Step 5: *With only the triangle of highway and parking lot left, he begins to add light strokes of gray pastel for the asphalt.*

Step 6: *He shows how he blends the pastel strokes with his finger to create a smooth tone. He will repeat this process of stroking and blending until he achieves the intensity of color he wants.*

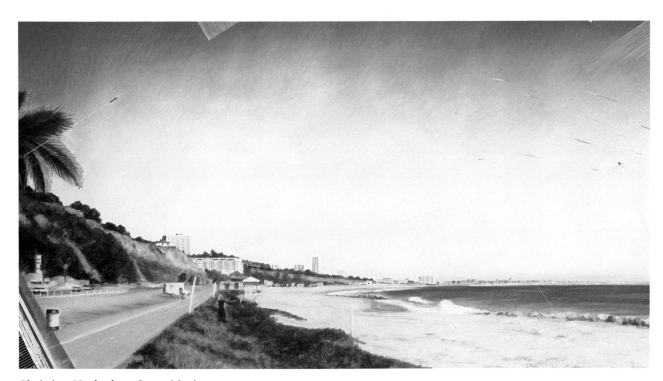

Christian Heckscher, *Santa Monica Bay,* 37½″ × 68″

Step 7: *Here is the finished painting, complete with abstract accents of pastel and collage.*

Christian Heckscher, *Nice Sunday,*
31″ × 41″

*Large expanses of blue sky are character-
istic of Heckscher's California paintings.
He achieves the intense blues with many
layers of blended color — blues, grays, and
violets. For the lightest blue at the horizon
there may be only one or two layers of
color. At the top of the painting where the
sky is darkest, the artist may need half a
dozen or more layers of pigment.*

Deborah Deichler, *Chum's Back*, 30⅛″ × 29¾″

FINISHING
Details and Edges

I don't usually believe in easy answers to artistic problems, but for the question of how to get crisp details in a pastel painting, there really is a simple solution: draw carefully and keep the tips of your pastels sharp. Pastel pencils, Nu-Pastels, and other hard pastels can be sharpened easily with a blade or sandpaper and the point makes rendering fine details as easy as possible.

TWO APPROACHES TO DETAIL

There are two approaches to detail in pastel painting. The first is to indicate basic details in the initial drawing or underpainting and include them in every further stage of the painting. The other approach is to develop the large shapes of the painting first and add the details on top at the end.

If one is going to locate the details first, the initial drawing must be finely developed, leaving nothing to chance. This requires planning and control of the medium. Most of the work should be done in medium to hard pastels so the underlying contours are not obscured or distorted. Often the details need to be reinforced or even re-drawn as the painting proceeds.

The other approach allows for more flexibility and experimentation. First the largest shapes are

laid in. Gradually the contours are refined and the smaller shapes are developed. Finally when everything else has been established, the smallest details are placed.

In planning for detail in your composition, it is good to be aware of the hardness of your pastels. If you want to use pastel pencils or sharpened hard pastels for drawing your details, you cannot build up thick layers of soft pastel first. The hard pastel will not adhere well to the very soft pigment. You can spray with fixative for a more receptive surface, but that may change the texture and value of your colors. Soft pastels can also be sharpened and used to draw fine details, but they will not retain a point for long.

HARD AND SOFT EDGES

The easiest way to make a hard edge is to draw a single, crisp line

for the contour and then fill in that shape with color. The sharpest lines possible will be made with a pastel pencil or hard pastel stick sharpened to a point and used against a straightedge.

Another way to create a sharp outline is by using a paper cut-out. Suppose you are painting a building in the foreground that calls for crisp edges. Begin by laying in and blending your background, perhaps spraying it lightly. Cut out a piece of paper (fairly sturdy) in the shape of the negative space around the building. Lay the cut-out on that shape and hold it in place while you paint the building. When you are done, lift off your cut-out and your building will have sharp edges.

For the softest edge, move your blending tool in a motion perpendicular to the edge or draw strokes of hard pastel on top of your edge, in a different direction.

Jody dePew McLeane, *Waiters Setting Up*, 15″ × 18″

Whatever detail McLeane uses is very loosely rendered, only as much as needed to establish the subject.

When do you want to use hard edges and when do you want soft? If you are working with the illusion of three-dimensional space, you will want harder edges in the foreground, where the eye sees things most clearly. As objects recede in the distance, give them less distinct outlines.

This is also true with small three-dimensional shapes: the areas closest to you will be sharpest. If you are painting a flat circle, mark the entire circumference with a distinct edge. To make the same circular shape look solid like a ball, soften the edges.

The same rules about receding space hold true for details as well. Up close, details are clear to the eye, so they can be drawn exactingly. As objects recede into the distance, the details become less and less clear, so they should be painted less clearly or even eliminated altogether.

Using hard edges or details throughout a piece tends to flatten out the image. So use outlines sparingly, or draw them with broken lines that let some of the colors flow into each other. It is possible to show edges without the use of outlines at all, simply by butting one color up against another. The contrast between the two colors creates the sense of a line where the shapes join.

Another use of sharp edges is for emphasis. If most of the painting is done with blended strokes, the few areas where you make distinct edges will become a focal point.

With pastel you can be as precise or as loose with details and edges as you choose. Be deliberate in your use of edges and details. They can add much more to your paintings than just factual information.

Christian Heckscher, *Windy Day,* 24″ × 31″

Heckscher gets the fine edges for his architectural forms by drawing or blending against a straightedge or paper cut-out. He places the ruler or piece of paper over the negative space, then paints the object, spraying the newly painted area with fixative.

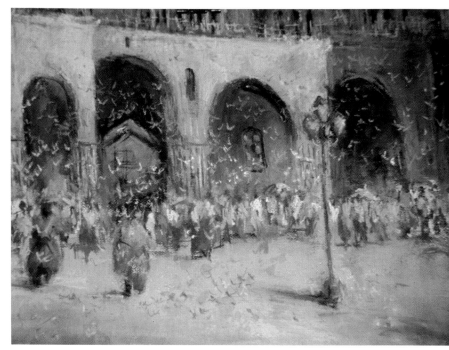

Sidney Hermel, *Piazza San Marco,* 18″ × 30″

At first glance this painting seems to be brimming with details but when viewed closely, we see that details are just suggested by Hermel's lively strokes.

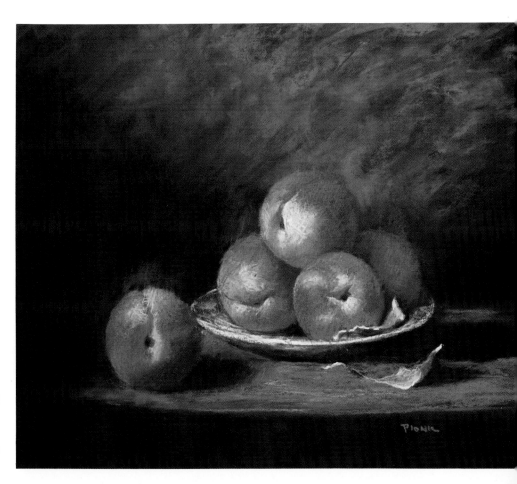

Richard Pionk, *Peaches*, 11″ × 12″

Here we see how Pionk combines hard and soft edges to create the illusion of space. The edges and details that are closest to the viewer are drawn sharp; those that are further away are blended.

Edith Neff, *Cumberland Freight Station, August*, 27½″ × 32″

In the sky, as well as the buildings and foliage, you can see the lyrical quality of Neff's curving, crosshatched strokes. But the crisp detail is still evident from her carefully rendered charcoal drawing.

Rendering Fine Detail

JANE LUND

A passion for detail is the key to Jane Lund's virtuoso pastels. Her still lifes and figures go beyond realism in their attention to detail. Lund works up to a year on each painting, adding one tiny stroke at a time.

She explains, "The various layers of color are built up slowly, beginning with Rembrandt soft pastels, then blended in with hard NuPastels. Quite a bit of time is spent sharpening the pastels with an X-Acto knife in order to achieve the fine detail. As I do not use fixative, the pastel retains its intrinsic softness. Careful inspection of the surface of many of my paintings will reveal the worlds within worlds that I see in each object."

Lund likes to work with the subject before her so she can constantly compare the painted image: Is each section expressive of the subject? Do all sections balance with each other? It is not enough to paint every single detail, but all of those details must work together for a unified painting.

Step 1: *Lund begins a painting with a series of small sketches, one of which is enlarged onto newsprint paper. The composition and the scale of the painting is determined. She then transfers this drawing onto Canson paper using a light cobalt blue pastel. She refines the drawing with the light cobalt and a kneaded eraser. Lund feels that the light blue lines are easier to see as the painting progresses.*

Step 2: *Lund paints with the painting upright, one section at a time, usually working from top to bottom to avoid the dustfall and from left to right to have a place for the mahlstick that supports her drawing hand.*

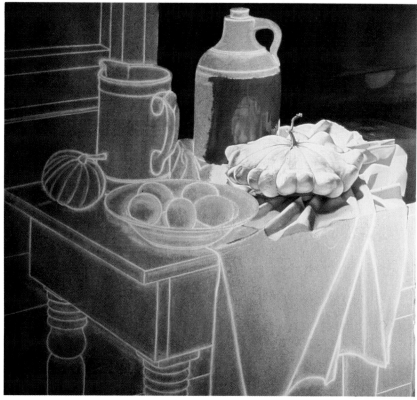

68

The mahlstick she uses to support her hand is made from a wooden dowel with a rubber cane tip attached to the end.

These close-ups demonstrate the rendering of an object. In the early stages Lund tries to put in all the visual information she can see. This usually creates too intense an image, so she softens it with a "glaze" of tiny strokes that blend the details into a more unified appearance.

Step 3: *After completing the squash and jug, she starts the eggs and pitcher. She wanted to paint the squash and eggs early in the painting so they would not spoil before she was able to complete them.*

This view of Lund's worktable shows some of the tools she uses. The X-Acto knife is used for sharpening pastels like those in the foreground. She changes knife blades often and also uses the paper border of her painting for fine tuning the points of chalk. The odd-shaped device in the center of the table is a car battery filler bulb which she uses to blow away excess pastel dust.

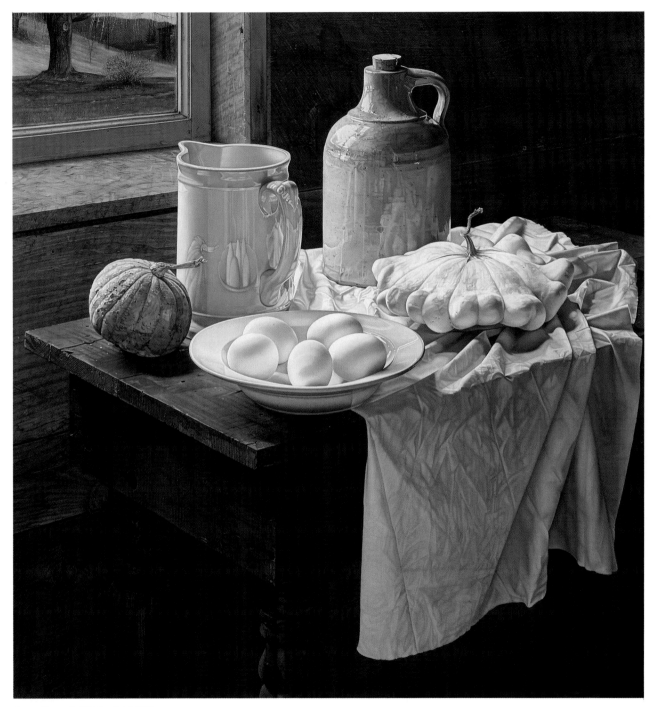

Jane Lund, *White Still Life*,
30½″ × 29¼″

Step 4: *She continues to add one section at a time until she has completed the entire composition. The final painting is unified, despite the piecemeal approach, because of the sustained concentration on details throughout the painting process.*

Deborah Deichler, *Immaculate Grinding Wheels*, 26″ × 19″

VALUE
Laying the Foundation

Because of the intensity of color in pastel, some people overlook value, but value is the foundation, the skeleton on which color and texture are hung. Without value there is nothing to support the rest.

By value I mean, of course, the relationships of lights, darks, and middle tones. Every stick of pastel has both color and value. By learning to see and design with value, we create strong compositions. Along with the pattern of colors, each painting should also show a strong design of lights and darks.

TWO APPROACHES TO ESTABLISHING VALUE

The classical method to establish value is to separate value and color, developing your values first. Using a single stick of dark color, or a monotone underpainting, compose the overall pattern of lights, darks, and midtones before adding any local color.

Once the values are down, you can begin to add strokes of local or actual color. You can either spray the initial layer of value with fixative to keep it separate from your later colors or you can leave it unfixed to blend with subsequent colors.

Painting a face, for example, you might render all the contours and planes, highlights and shadows with a basic brown. After you have created a solid image in the one color, you can add local colors, ochres and reds for the skin, purples and greens for the shadows, and so on.

The second approach is to paint directly with color, planning each stroke of pastel for value as well as color. Doug Dawson simplifies this approach by starting his painting with just a few colors of varying values, often just a light, a medium, and a dark. He first divides the composition into a few large value areas with those colors, then gradually breaks the painting down into smaller and smaller shapes as he adds more colors. Throughout the painting he is aware of the balance of his values.

Some artists establish both their value and color in just one or two layers of strokes. This technique requires careful planning. Preliminary studies—photos, sketches, and small paintings—provide valuable guides for the final execution.

OTHER FUNCTIONS OF VALUE

Value has many other uses besides building composition. Some of those are:

Depth. Value contrast decreases as objects recede in space. In a landscape, the foreground will show the greatest value contrast; very dark or light objects and shadows will usually be up front. As the space recedes, objects tend to gray.

Focal Point. In a predominantly dark area, a light spot will become an automatic focal point and vice versa.

Deborah Deichler, *Dorinne Seated with Mirror,* 19″ × 26″

In this painting much of the interest is due to the strong highlights and shadows created by the single light source. The composition becomes an interesting arrangement of light, dark, and gray shapes.

Sidney Hermel, *Pete's Tavern*, 24″ × 36″

Light. Light is shown by where and how strongly you place the darks and lights. To show a light source shining from the right, paint all highlights on the right side of objects and make all shadows fall on the left. To show bright sunlight, keep the values light with some very dense shadows. To show night, use mostly darks with strongly contrasting spots of color.

Drama. Value contrast enhances drama. When we describe someone as boring we may say he has a gray personality, no bright lights or heavy darks to spark our interest. A painting is the same. Value contrast adds interest.

CHOOSING PAPER

One advantage the pastel artist has is the variety of colors, values, and textures of paper available. Pastel works over black, white, or any color of paper. I have found that it is easiest for me to visualize my total pattern of value on a middle-value paper. Also, I can paint directly with lighter or darker pastel sticks.

I usually choose a colored paper that either complements or harmonizes with the predominant colors of my composition. However, if you have never executed a painting on black, try it. The contrast with the black makes each stroke of pastel assume its greatest brilliance. The contrast is difficult for a beginner to control, but with practice, it provides wonderfully dramatic effects.

Hermel develops his paintings from on-the-spot studies of his subject. Here are two value studies he made to help him see the pattern of values for the final composition.

Bill James works from color photos or slides, but before he proceeds from the color study to the color painting, he breaks the values down in one or more pencil sketches. In these two studies he examines the shadow pattern on the face and also the relationships between the light skin and the dark water.

Bill James, *Bryan in the Pool*, 34″ × 40″

Step 1: *Doug Dawson begins this piece by drawing guidelines for horizon and perspective. Then he roughly blocks in his darkest shapes. He says, "Value is the single most important element. If you have a good use of value, you can get away with using almost any colors."*

Step 2: *For his middle values he uses red and green. He is still only concerned with general shapes and values.*

Step 3: *With light blue and yellow he fills the spaces where the lightest values will be. He also solidifies the darker shapes.*

Doug Dawson, *Near Times Square,* 33″ × 35″

Step 4: *Dawson finishes the painting by refining the shapes, values, and colors that he established at the beginning, maintaining a balance of values for the overall design. Dawson decided that the total painting was too dark, so he added the large shape of reflected light on the left.*

Richard Pionk, *Persian Vase and Bittersweet,* 15″ × 15″

This still life by Richard Pionk goes from very light to very dark values. The lights were easy to achieve with soft sticks of light-colored pastel. However, the darks were more difficult because of the narrower range of dark colors and because the darker sticks are harder and thus less opaque. Pionk resolved the problem by painting very dark areas in his underpainting and working over them with just a few applications of pastel.

VALUE STUDIES

Preliminary studies are always helpful in developing the values in a painting. When you look at a figure or scene, reduce the image to values. Using pencil, charcoal, ink wash, or a single color of paint or pastel, create a small value study of the composition. These studies will help you lay out the initial composition and you can use them as a guide as you develop the painting.

You should know where your strongest lights and darks will be from the beginning. Pastel works well for adjusting middle values as you go along, but it is much harder to cover over bright lights and deep blacks. If you do need to make a drastic change in values during painting, spray the incorrect area with fixative. This will give you a receptive surface for new strokes of pastel.

There are three ways to check the value contrast of your paintings: You can photograph the finished painting in black and white; look at the painting through red cellophane, which also reduces the image to black and white; or you can squint your eyes to reduce the color intensity, making it easier to see overall value.

One last note about value: light values are easy to create with pastel. There is a range of very light colors available and many are soft pastels that go on in rich, opaque strokes. Dark values are not so easy. There are fewer dark colors available and they are usually fairly hard pastel sticks, which make it harder to achieve dense color. Some artists enlarge their selection of darks by making their own (see Chapter 2). Another solution is using an underpainting with strongly developed darks, then you can create solid dark values with fewer layers of pastel. A third possibility is to work on very dark paper. You may have to use many layers to achieve your lights, but that will be easier because of the softness of the light pastels.

Value Contrast for Drama

DEBORAH DEICHLER

Deborah Deichler is a classical realist who plans each piece carefully, slowly building it to a higher level of refinement. Each painting is preceded by a thorough study of the subject. She feels she must be familiar and comfortable with the model and props before she begins to paint. For *Dorinne With Pearls* (next page) the first step was a five hour session with the model. The artist sketched and took about one hundred photographs and slides to record pose ideas and close-up details of features. After completing the active study, Deichler "lives" with the subject, looking at the photos and possible backgrounds, often for months before she is ready to begin.

Deichler works on the finest paper she can find, often Roma, a heavy rag paper that comes in an assortment of rich colors. She starts with a simple drawing to mark contours of the figure, shadows, important details, and the main value shapes. She works gradually from hard to soft pastels. She is careful not to use soft pastels until the last moment, because once they have been applied to an area, the paper is no longer receptive to the harder sticks.

After she has rendered the initial drawing, she further develops the values in a range of grays. This approach of developing values first with neutral colors before adding local color is a classical oil painting technique that Deichler adapted to pastel.

She continually blends and rubs the pastel into the paper so the color will maintain a smooth surface with no distracting strokes. In pastel *paintings* she eliminates all signs of paper texture; in her looser pastel *drawings* she allows some of the paper grain to show through.

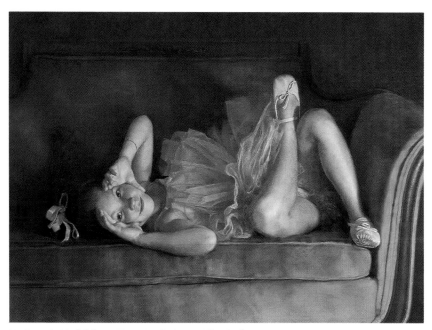

Deborah Deichler, *Kate Reclining*, 23″ × 31″

Deichler builds her paintings with small strokes that she carefully blends together. She wants the surface of the painting to be smooth so she can fully develop the textures within her subject. Value contrast is used here to focus interest on Kate.

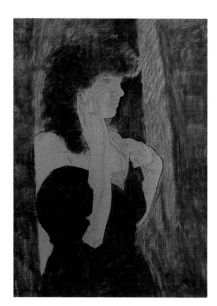

Step 1: *For "Dorinne with Pearls," Deichler starts with a dark gray drawing, then, using soft and medium hard charcoal sticks, she blocks in the darks, indicating the light-dark pattern that will carry through the rest of the painting. The black velvet dress is the darkest value and the skin tone, the lightest.*

78

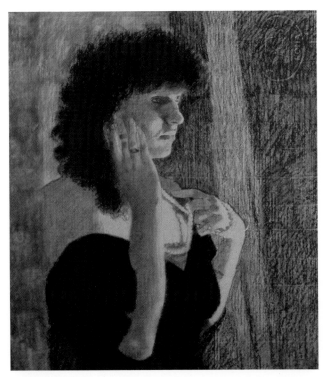

Step 2: *Deichler adds limited color, using NuPastels and some soft pastels, crosshatching to get the color on quickly. The hair and dress are solid black NuPastel. A limited palette sometimes helps in achieving a strong value statement.*

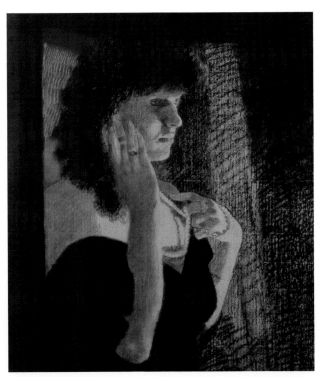

Step 3: *The top of the screen line in the background is lowered to focus interest on the center of the composition. The almost black/white contrast begins to be seen here, putting the subject in a dramatic light.*

Step 4: *She lightens the light valued flesh areas with creamy pastel pencils and dulls the background to increase contrast.*

Deborah Deichler, *Dorinne with Pearls,* 19″ × 25″

Step 5: *The white highlights on the jewelry are emphasized using a soft pastel sharpened to a point. Deichler accentuates the darkness of the hair, dress, and shadowy environment for contrast. The result is a mysterious, dramatic portrait.*

79

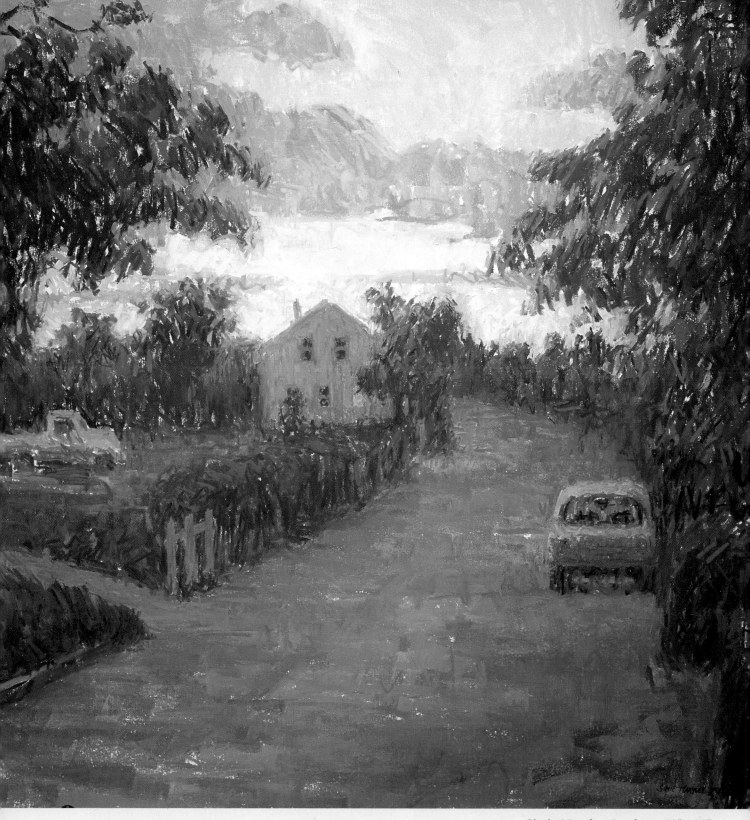

Simie Maryles, *Sundown*, 19″ × 19″

LIGHT
Illuminating Your Vision

It is light that makes it possible for us to see, yet in the most intense light we also lose the ability to see. Objects and colors look washed out. Between these two extremes are a variety of lighting conditions that provide inspiration and challenge for the artist.

There is consistency in light and shadow because light travels in straight lines. If the light shines from the left, highlights will be on the left and shadows will fall on the right. Light becomes more com-plex when it is diffused or reflected in another direction or when there is more than one light source. An artist can spend years trying to see and portray light accurately.

COLOR TEMPERATURE

Every source of light has a warm or cool cast to it. If you shine different kinds of light bulbs on a white sheet of paper some will appear warm, almost yellow; others will be cool, bluish.

The shadows cast by a light will appear to be the opposite tempera-ture from the light source. So if the brightly lit areas of your painting are all warm, then the shadowed areas should all be cool. Some pas-tellists simplify their painting by dividing the palette into sticks of warm colors on one side and cool colors on the other. This helps them maintain consistency in their painting and thus makes the light more believable.

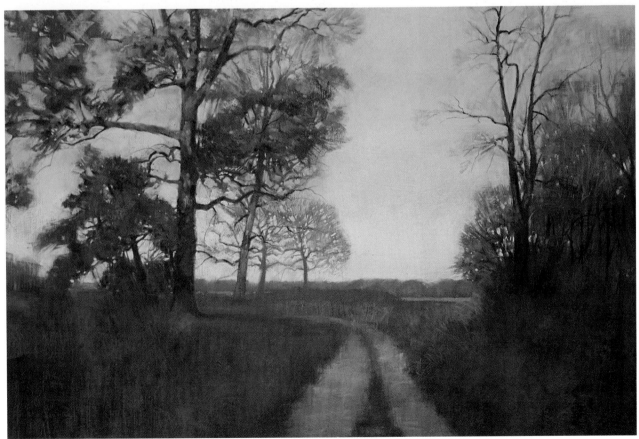

Robert Frank, *Morning Light,*
21" × 31"

What makes the sunlight apparent in this landscape are the contrasting areas of shadow. It is the play between highlights and shadows that establishes light; one will not work without the other.

Sally Strand, *Sun-dried,* 28″ × 40½″

Strand solves the problems of painting complicated images of light and motion by reducing everything to simple patterns of value. Color is important, the soft pinks and blues giving a gentle feel to the painting, but value is the key, especially the bright highlights that convince us of the sunlight.

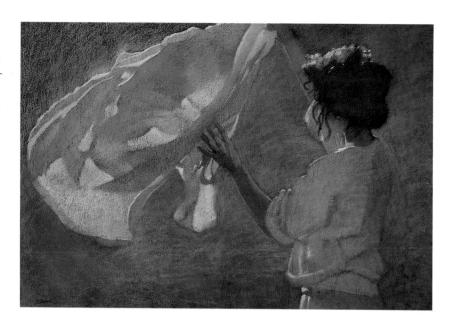

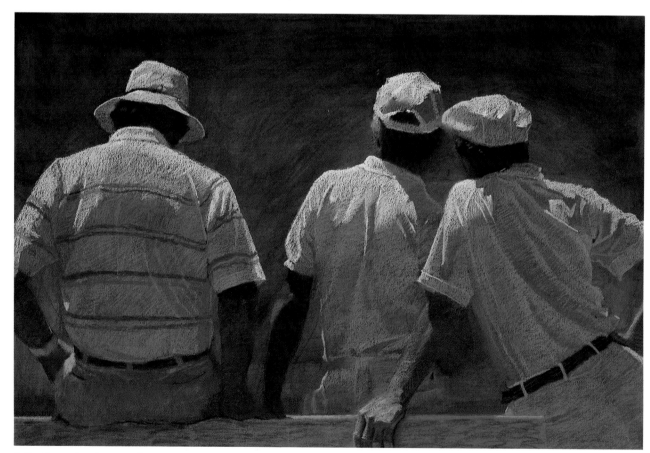

Sally Strand, *Men in White #3,* 28″ × 42½″

One of the characteristics of Strand's paintings is the use of glowing whites. The highlights are never actually painted with pure white, but are done in very light colors—blues and violets here.

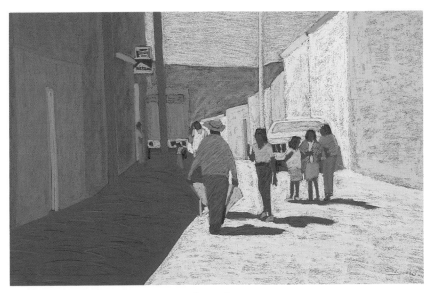

Tony Ortega, *La Calle Angosta,* 28" × 40"

In this painting, Ortega has simplified the pattern of light and shadow and used that as the basis of his composition. Notice how he has divided all his colors into warms for the sunlit areas and cools for the shadows.

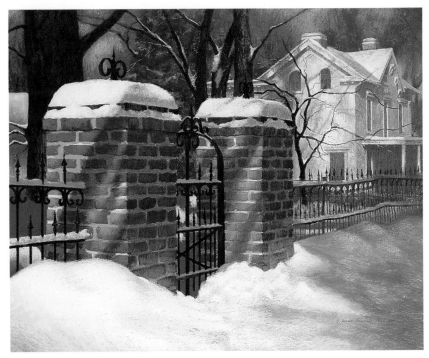

Barbara Geldermann Hails, *Gate Vista,* 24" × 30"

Snow is a very reflective surface, as shown by these very bright sunlit areas against the much deeper shadows. Hails never uses pure white, black, or gray. Instead she creates the impression of them by combining strokes of several colors of the appropriate value, such as the very light yellows and lavenders for the sunlit snow.

SHOWING VOLUME

Light can be a key element in showing volume. On a rounded object, it is the way the value and color gradually change as the light rays hit the rounded surface that makes the curve convincing. Pastel works well for this because you can blend lighter strokes into adjacent darker strokes leaving no discernible edge between the values. Thus you can create the appearance of a smooth surface bending in space.

For flat areas, one smooth, even area of solid color or value will appear as a flat plane.

In lighted areas (except where the light is so bright it washes out all color) details will tend to be clearer. In darker areas details will tend to be more obscure. In these darker areas you can use looser strokes or smear your strokes with a finger or brush.

CONSISTENCY

The most important element in establishing the illusion of natural light is consistency. If you start with a light source on the left, continue to use light from that direction. If you begin with warm light and cool shadows, continue to use warm colors for highlights and cool for shadows throughout the composition.

If you paint a landscape with a late afternoon sun—a low sun that casts long, dark shadows—be sure that every object in your scene is casting that same type of shadow.

The best way to learn to paint light is to observe how it actually looks in nature. Take the time to observe the differences between light at dawn and at noon, outdoors in the sun and in a dark room with a candle. Notice the patterns of highlights and shadows. Let light itself become a subject for your paintings.

Making the Ordinary Sparkle

SALLY STRAND

Light is the essence of Sally Strand's art—ordinary people and situations made extraordinary with brilliant light and shadows. Her subjects reflect life near her Southern California home, people in casual poses on patios, beaches, and bowling greens. With the bold value contrasts from a strong overhead sun, these unremarkable people become intriguing arrangements of color, shape, and value.

Strand begins with photos and sketches of likely subjects. Because she is capturing candid moments, gesture is a primary consideration.

As she develops the painting, she builds up the lights and darks. She doesn't use white for her brightest highlights; instead, she combines strokes of her lightest colors, which look like white because of the contrast with darker surrounding values.

For darks she may start with a layer of charcoal strokes, then she enlivens the shadows with colored strokes on top of the black. For less intense darks, she uses a dark-colored underpainting or she simply layers strokes of various dark colors.

Details are important only insofar as they establish the situation. Rarely are any details rendered with fine precision, except for the accents of bright highlight that enliven the composition.

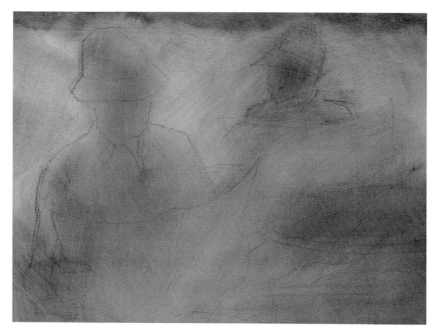

Step 1: *Sally Strand says, "I use Arches 300-pound watercolor paper, cold-pressed, stapled to a piece of plywood. My basic lay-out is drawn in charcoal and spray fixed.*

"I do a watercolor underpainting with a 3-inch housepainting brush. It is not very involved. I think in terms of large value areas and color temperatures—cools to go under the warm wall and a warm shadow on the figures and foreground."

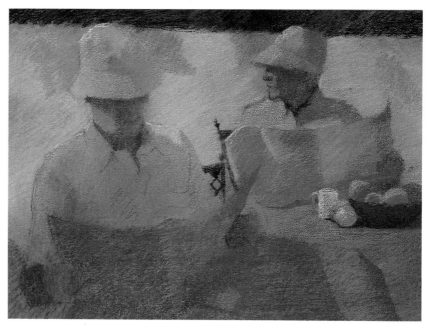

Step 2: *Here Strand is establishing the major values. She is aware of her limitations, that only a certain degree of light can be attained with pastels, so she is constantly judging everything against the lightest light spot. She does not want to lose the center of interest by getting too light overall, so she adjusts the value of the light background down to allow her lightest lights to stand out. Fixative is applied.*

Step 3: *Here Strand is adjusting shapes against each other, going into more detail, but still trying to maintain the big pattern. As she increases contrast she tries to keep the light pattern and the dark pattern separate, but working together. She uses lots of layering in the shadows, allowing some of the watercolor wash to show through, as in the shirt of the man where the warm wash is coming through the cool blues and violets on top. She sprays with fixative.*

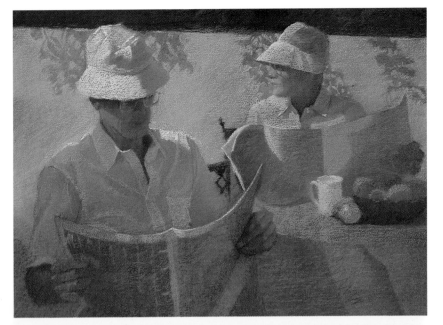

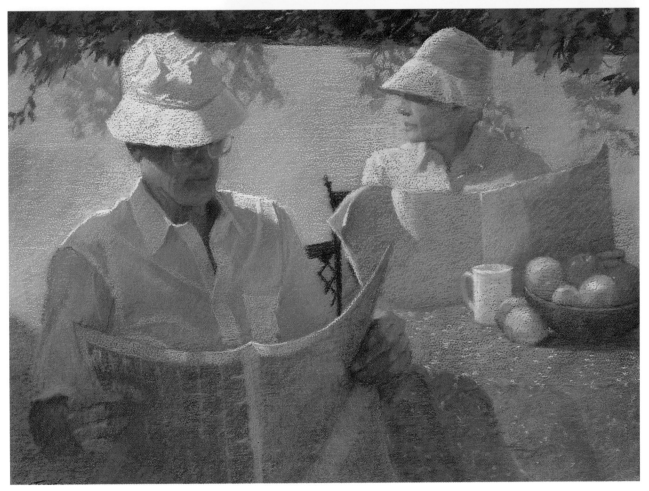

Sally Strand, *Morning News,* 20″ × 27″

Step 4: *Strand adds more details, always careful to step back and look at the painting as a whole. She sprays fixative one last time before adding the highlights. The lights on the man's hat are to be the lightest lights so Strand is careful to keep all other highlights secondary. This constant balancing of value and color is what makes the light in Strand's paintings so believable.*

Filling Landscapes with Light

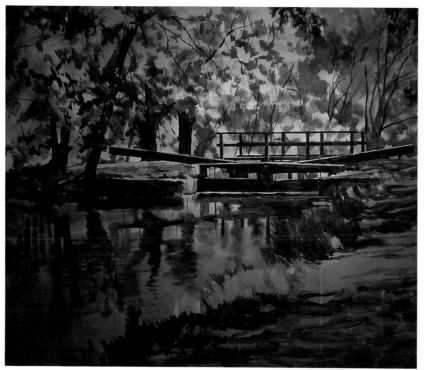

Step 1: *The first step is painting the composition in acrylic. Hails uses slightly darker colors and values than the final pastel will be. The light pastels will have increased brightness because of this contrast.*

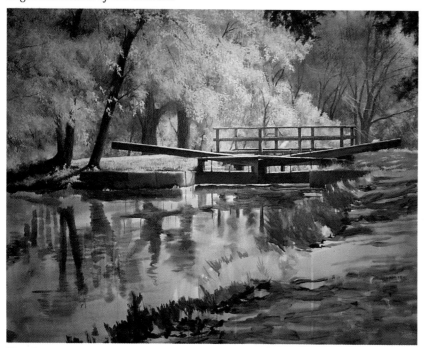

Step 2: *She works from upper left to lower right to avoid smudging the pastel, completing each section totally before she moves on to the next. She uses color temperature as well as value to distinguish light and shadow, such as the warm tones of yellow and green in the sunlit trees on the left and the cooler blues and greens in the shadowed trees on the right.*

BARBARA GELDERMANN HAILS

A landscape is composed of fields and trees, ponds and rivers, but Barbara Geldermann Hails sees nature as surfaces on which light falls. She says that light presents the challenge that keeps her fascinated with painting. For Hails, the key to luminosity is small overlapping strokes of many colors.

She begins each painting with a careful drawing transferred to sanded, four-ply museum board and then does a full-color underpainting that details all the shapes, colors, and values of the composition. The sanded board will hold up to six layers of pastel. She arranges her pastels by value and does not use any white, black, or store-bought gray.

To create the feeling of bright sunshine next to shadow she uses another special technique. First she strokes a bright tone (of a slightly darker value than she will eventually want) over the entire sunlit area. The next layer is a lighter pigment covering the same area, but leaving a rim of the first color next to the shadow. The third layer, even lighter, again covers most of the sunlight but leaves a rim of the second color showing. The effect is of brighter and brighter light, precisely as we experience in nature. The result of this careful assessing of light and color is an image that looks solidly real, but glows with light.

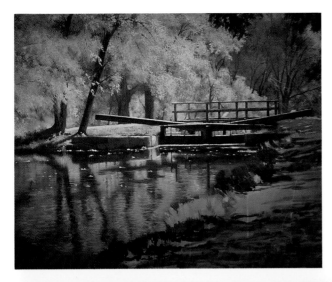

Step 3: *She moves on to the water in the lower left, adding green for the cool reflections of the foliage above. She uses horizontal strokes on the water to establish the flat plane of the pond's surface.*

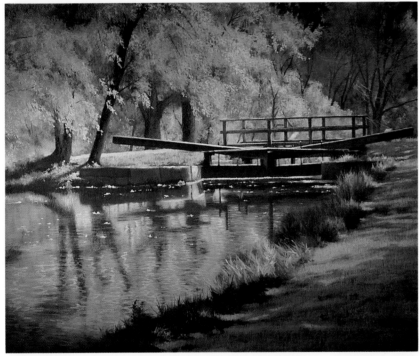

Barbara Geldermann Hails, *The Lock,* 32" × 40"

Step 4: *The last section to be finished is the path on the right side. Notice the dappled sunshine on the path. Hails says that even on a cloudy day with intermittent sunshine, light invades shadow areas.*

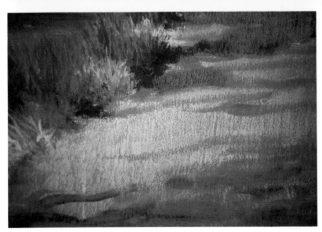

In this detail we can see the first layers of pastel applied to the path. She uses warm orange for the light areas and cool blue for the shadows. These are darker values that will be overlaid with lighter colors.

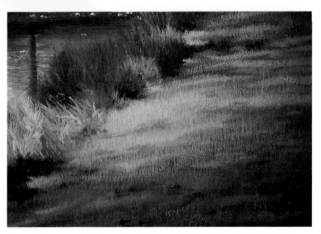

Later in the painting's development, the color of the path has changed. However, the underpainting still contributes to the value and color temperature. Hails is careful not to leave hard edges between light and dark areas, providing a smooth transition with strokes of middle values.

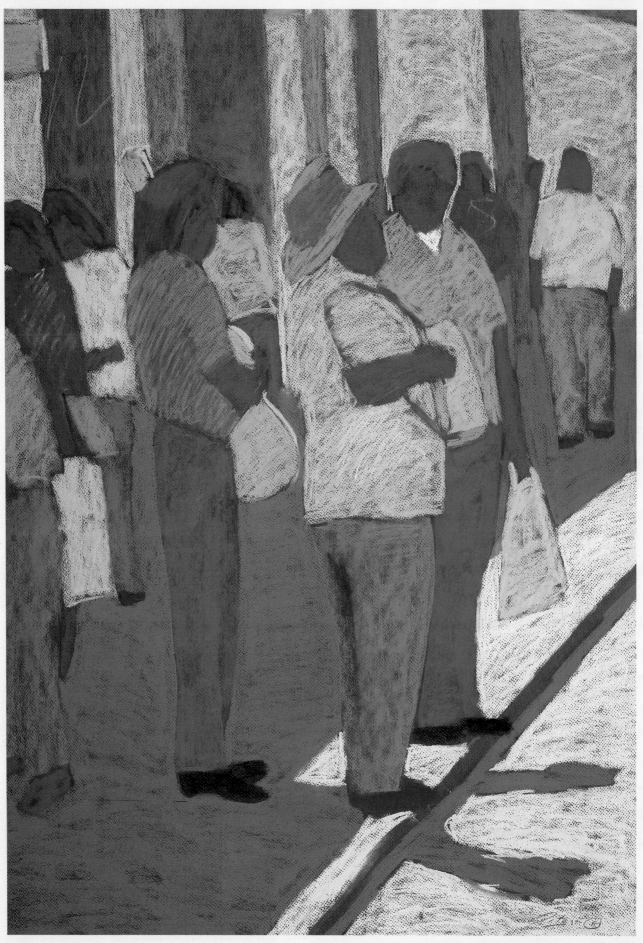

Tony Ortega, *Los Musicos*, 40″ × 28″

COLOR
A Rainbow at your Fingers

When I hear the word "pastels" my first image is of color—trays and trays of different colored pastel sticks, a veritable rainbow to draw from. Looking through the drawers at a good art supply store, it seems there is no end to the variety of colors. So it's strange that there's always a point when I am well into a new painting and I look for the right color for a particular spot and I cannot find that color. Dealing with that irony successfully is what makes a fine pastel artist.

When you find that with this vast selection of colors, you don't have the exact one you need, you are forced to blend colors in inventive ways. With wet media you can blend the pigment on the palette.

However, with pastels (unless you make your own) you must create new colors with the painting. You add layers of different colors to achieve the exact tone or value you want, or stroke lines or dots of different colors next to each other, either blending them on the surface or leaving them separate for the eye to blend.

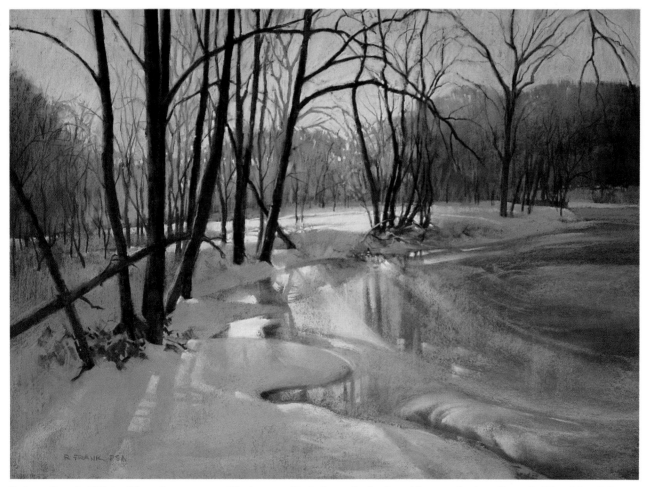

Robert Frank, *Winter Warmth*, 21″ × 29″

The process of painting color begins with your selection of pastels. The sticks of pigment you choose will determine the final color because you can't change the colors by mixing on a palette or diluting. In his paintings Robert Frank prefers the gentler tones that are traditional to pastel, along with a few intense yellows and some darks for contrast.

MIXING COLORS IN THE PAINTING

Whenever you stroke one pastel color over another, the colors will blend together. Greatest blending will occur when the top layer is painted with medium to hard pastels because the color they leave behind is not as dense as soft pastels. Very soft pastel over hard pastel will give the least blending; the opaque strokes of soft color will hide most of what it covers.

If you are physically blending with a finger or cloth, you can place strokes of two or more colors on top of or next to each other. When you smear them together, the separate colors will disappear leaving you a smooth layer of blended color. (Strokes of very hard pastel that are pressed deeply into the paper may resist blending.)

For visual blending, place individual strokes of different colors next to each other and leave them unblended. As you back away from the paper, those different strokes will seem to blend into the desired color.

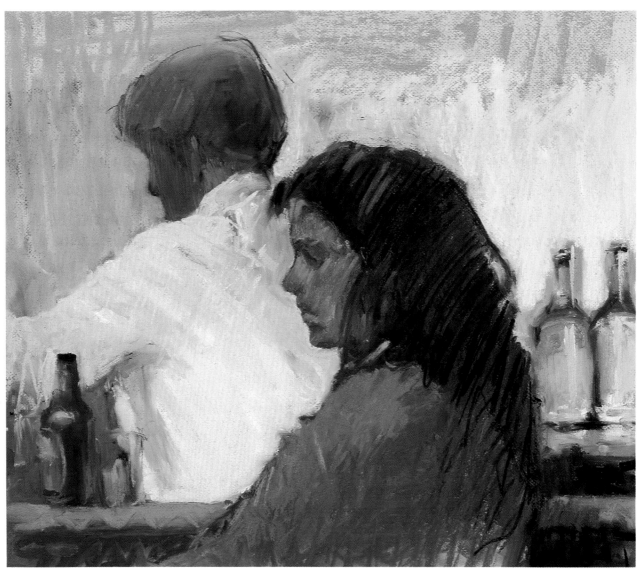

Jody dePew McLeane, *Woman at the Bar*, 20" × 24"

For McLeane, color is used to convey emotion, drama, focal point, and movement. She lets the intense colors blend visually to add interest. Our eye is drawn to the woman's face by the strong reds and oranges. But to keep our eye from settling there and not moving, she has added bright yellow accents in the bottles and background as secondary points of interest.

SIMPLIFY YOUR COLOR

The most common way to get into trouble with color is to use too many colors at once. Beginners tend to think of their whole box of pastels as their palette; but a basic way to achieve color harmony is to physically separate those few colors which will make up your palette for a painting.

You can start by picking out only three colors of different values. You might want to try an abstract sketch to see if this combination is pleasing. Then develop a value pattern, covering the whole surface with these three colors.

Add other colors cautiously. Too many colors lead to chaos. When you use a new color, look for additional places where that color can be used, to help assure color harmony throughout.

Simie Maryles, *New Shoes*, 14" × 12"

Maryles has simplified her color scheme by choosing a blue (cool) dominance in the background to offset the warm yellows and white of her focal point (the child).

Sally Strand, *Men in White #4*, 41½" × 28"

Strand has used a strong underpainting of warm brown as a counterpoint to her cooler highlights. The light blues (to convey white) appear even lighter and brighter against the brown. She uses the technique of scumbling, pulling the chalk across the top of the textured surface of the paper, leaving the lower dots of the underpainting to show through.

USING A COLORED GROUND

Artists who use a colored paper or board will find that the color of the ground affects all later colors. For instance, putting a blue mark on gray paper has a different impact than the same blue on brown paper. Using the opposite color temperature, blue on brown, will make both temperatures seem stronger and the colors will seem to vibrate against each other.

Try the same pastel colors on different colored papers. Notice how the pigments themselves seem to change against different backgrounds.

When Robert Frank prepares a painting surface, he adds a colored tone to the primer. He says, "The toned ground is used as an underpainting and penetrates all shadows, objects and atmospheric lighting in its path. Every color applied over this continuous tone is affected either by warmth, coolness, or value. For instance, in the case of a warm reddish paper, the application of a cool greenish ochre color will appear much cooler than if it were applied over a cool green or blue paper.

"Continuous practice to compensate for these different grounds is needed to train the eye to see this effect. Color tonality is probably the single most important and difficult lesson in the application of pastel painting."

Sidney Hermel, *On the Avenue, 30" × 24"*

Hermel says, "By abstracting and simplifying the background and using rich color in the foreground interspersed with complementary colors, I believe I was able to reach my goal of delineating the excitement of the city, its movement and light."

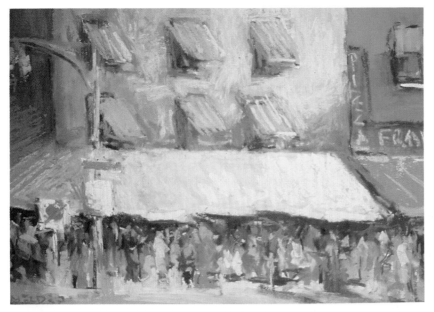

Sidney Hermel, *Kim's Market*, 24″ × 30″

*Hermel creates space under the brilliant yellow awning with some deft strokes of dark.
He uses active, bright, vertical strokes to create what we readily recognize as people in
motion.*

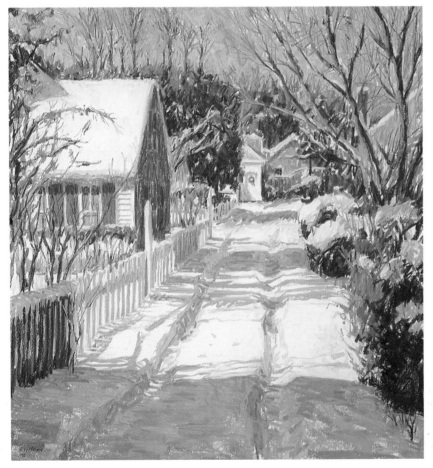

Simie Maryles, *Atwood Lane in Snow, Winter Sun*, 15½″ × 14″

*Here, Maryles makes use of some very colorful darks to contrast the brilliant light
of the snow.*

COMPLEMENTARY COLORS

A complementary ground can enhance the warmth or coolness of a color, as stated above, but complements can also be used to "gray" or neutralize a color. For example, if you are painting a field of grass, you might use bright, pure green in the foreground. In order to make the field recede in space, you will want the further green to be duller, "grayed." So in the distant area you can blend some strokes of red in with the green. You get the maximum graying effect by blending with a cloth or finger.

A somewhat different effect occurs when you place individual strokes of complements next to each other and leave them unblended. The colors seem to vibrate or bounce off of each other. This effect is strongest when both complements are of the same intensity. From a distance, the strokes may visually blend into one grayed color, but up close the individual colors energize the surface.

LIGHT COLORS, DARK COLORS

Many artists avoid the use of pure white or pure black in their paintings, believing that black and white lack the richness that colors have. With pastel it is easy to avoid white, as there are many wonderful, very light colors available. When you place very light greens, pinks, lavenders, or other colors next to dark values, they look like white, but have more resonance.

Darks are harder to achieve because it is more difficult to find very dark values of soft pastels other than black. I often crosshatch layers of deep red and deep green to get my darkest values. Some artists combine layers of black strokes and colored strokes. There are also ways of making your own sticks of dark color (see Chapter 2).

Color with a Punch

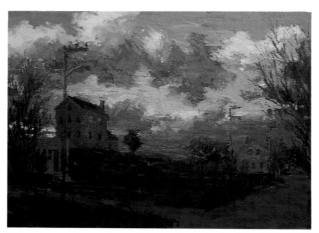

This color study was done with acrylic and pastel. Both the study and the painting were done from a combination of photographs, drawings, and observation.

Step 1: *Maryles says, "I always begin with a very loose sketch, here in acrylic, which is a kind of notation to myself of placement and composition. By keeping things loose and nonspecific I can see my idea without locking myself in."*

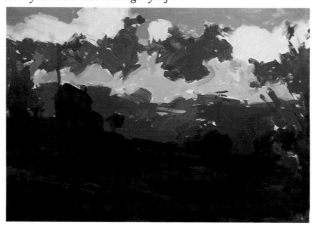

Step 2: *"This is my acrylic underpainting, which I have used because I'm looking for a warm red glow. The acrylic maintains its integrity and doesn't blend with the pastel to muddy it."*

SIMIE MARYLES

Look at a Simie Maryles painting from a distance and you see a solid, smooth-looking image, but up close the same painting breaks down into thousands of separate dabs of color, as was typical of the French Impressionists.

Maryles loves pastel because it allows her this uninhibited use of color. She says, "I did pastel portraits for a living for eight years. We were required by demand of the public (it sold better) to work very tight and monochromatically.

"When I first went outside to paint a landscape, it was wonderful. I could exaggerate a drawing and punch a color any way I liked and no one would ever tell me there was 'something wrong with the mouth.'"

Her surface is generally rag illustration board, which allows acrylic underpainting, and a layer of ground pumice glued on with spray fixative. She mentions a favorite board, Rising, that has a relatively smooth surface. She says the pastel glides across the smooth surface and the board also has the strength for extensive reworking.

She likes working on a white surface, explaining, "The traditional pastel method is to start on a halftone surface. I prefer white because the colors are their most brilliant on white."

Maryles paints mostly with Rembrandt pastels, some Sennelier and Lefranc & Bourgeois, and occasionally NuPastels, broken and used on their sides.

Although she paints very dramatic skies, most of her subjects are more commonplace—flowered landscapes, snowcovered roads, New England houses and country inns. What makes them interesting paintings is the way her eye breaks down each scene into a sparkling array of colored strokes.

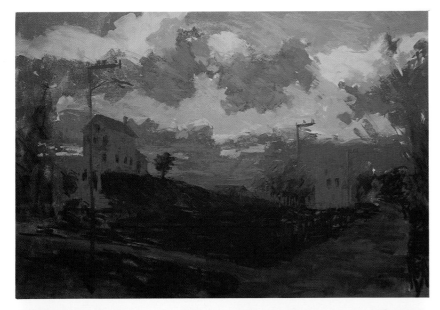

Step 3: *At this point the painting is still broad and simple, but finished enough to be understandable. Maryles has begun with pastels, laying in cooler colors over the warm reds and pinks of the underpainting, mostly using the sides of the pastels, stroking, gliding, sometimes sort of walking them along. The red underpainting ties things together and adds contrast.*

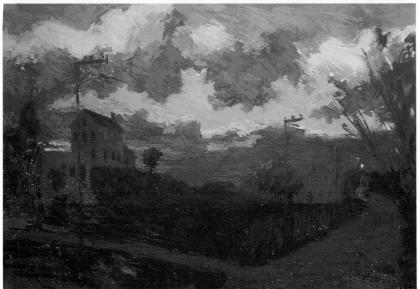

Step 4: *Maryles says, "As the painting progresses I am refining areas and 'focusing.' I've sprayed the whole painting to darken it. (I sometimes use fixative during the working process, but never in the final stage.) At this point it's sometimes a matter of adding and subtracting—you refine an area, but it becomes over-refined; so you wipe it out to simplify and start over. It's a matter of deciding where the emphasis should be."*

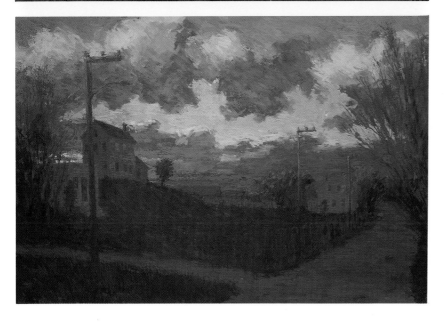

Simie Maryles, *Autumn Skies: Sunset on Alden Street,* 24″ × 36″

Step 5: *"There is more detailing, more fine branches in the trees, small strokes in the grass. I think it's quite interesting to compare the original small study (page 94, top) and this larger piece, the one being more spontaneous and immediate and the other much larger and more refined."*

Doug Dawson, *Berthoud Woods,* 33″ × 39½″

COMPOSITION
Putting It All Together

Create beautiful color, interesting texture, vital strokes, and dramatic values and your painting still will not work without good composition. No matter how strong each of the parts is, they must all fit together. Good composition combines the elements of movement and balance. The design must be interesting, but still comfortable to view.

This diagram shows how a simple, but interesting, division of space provides the structure for the painting below. The basic composition is just three triangles. No matter how complicated a finished landscape looks, it should be based on a simple underlying design.

COMPOSING WITH LINE OR SHAPE

Because pastel can be used to draw as well as paint there are two different approaches possible for developing a composition. The first is to draw all the contours of your design. Once you have rendered all the outlines, you can place the appropriate values and colors within the indicated spaces.

The second method is to avoid line and work exclusively with shape. In this method, rather than seeing and drawing the outside of an object, you learn to see and draw abstract forms. Your painting might first look like three or four big shapes. Then, as you refine your painting, these shapes would get broken down into smaller shapes.

You can also combine these two methods. I like to start my paintings with a quick gesture drawing. Then, using that drawing as a guide, I block in my major shapes, not concerning myself with exact outlines. As I paint, I go back and forth refining shape and line, as necessary.

Barbara Geldermann Hails, *Azalea Bank,* 24″×30″

97

COMPOSITION STUDIES

Preliminary studies are especially important in pastel. Pastel is a very forgiving medium, but it makes sense to avoid as much unnecessary reworking as possible. Beginning with a basic plan for the organization of shapes, values, and colors will make the development of the painting go much more smoothly.

COMPOSITIONAL ELEMENTS TO DETERMINE:

• *What kind of underlying structure to use.* Creating a basic geometric pattern, a triangle for instance, with the large shapes or focal points will help make the total image look unified.

• *Where to put your focal point(s).* A single focal point catches the eye. Secondary focal points move the eye around the painting. Focal points should be determined by abstract design as well as subject matter. Planning them ahead will enable you to intensify them with contrast of color, texture, and value.

• *How to balance lights and darks throughout the composition.* Placing all the darks in one area will make that section too heavy. All the lights in one area will pull the eye away from the rest of the painting. This can be adjusted as you go along, but drastic value changes in pastel can be a bit of a bother.

• *How to organize your color.* Pastel colors can become very chaotic because of the vast selection. Pre-planning helps you simplify for the strongest impact.

• *How to break up large shapes.* Regardless of the subject, no area of the painting should be left without visual interest. Large, flat areas can be dead holes in the composition. You can energize them even with subtle value and color changes.

Bill James, *Outside Leesburg,* 34″ × 32″

Especially with landscapes, where there is a profusion of small shapes and details, it is good to simplify the scene to a few main shapes. That is what James has done in this preliminary composition study. After he had divided his design into the main value shapes, he was able to proceed with concerns of color and texture.

Edith Neff, *A Sense of Absence,*
24½″ × 32″

*Most architectural paintings show all, or
at least most, of the featured building. In
this unusual composition, Edith Neff has
included only part of the structure,
thereby drawing attention to the details
rather than the building as a whole.*

Doug Dawson, *The Denver Parish,*
20″ × 22″

*Dawson does not believe in the "coloring
book approach" to composition—that is,
drawing outlines and filling them in with
color. Dawson works as much as possible
without line, dividing the surface into
four large shapes—sky, background,
houses, and foreground.*

Letting the Composition Evolve

MARY MORRISON

When Mary Morrison goes out looking for painting subjects, she thinks in terms of volumes and masses. She wants a fairly neutral subject where she can concentrate on raw shapes. She says, "I'm not painting objects, but rather color planes that will form an integrated work of art. Negative space carries just as much weight as positive areas."

The subject is only important as a place to start. During the painting process she alters or completely eliminates objects with no thought to the original scene. She says that the painting is important in itself, not just as a picture of something.

She adds many layers of pastel, continuously refining shapes and values. Before she goes on to each new layer, she sprays with fixative to provide a receptive ground for the next layer of color.

She applies color in unbroken shapes. She rarely uses her hand to blend, using instead strokes of harder pastel over softer pastel. The first strokes are Schmincke; these are topped with harder Grumbacher colors applied with a circular motion that minimizes separation of strokes.

Even after this blending you can still see the paper or acrylic underpainting in spots. She doesn't like the way blending by hand "grinds the pastel down into the paper." This way the pastel stays on the surface where the colors shimmer.

She says, "The primary reason I use pastel is the reflective quality of the pigments." For Morrison, each painting is an exploration of composition with the design evolving throughout the painting process.

Step 1: *Morrison works on Arches 555-pound rough. She blocks in the painting with a thin acrylic wash and paints over this in pastel. She establishes the dominant light-dark pattern of the composition, using very limited color. She says, "After I'd blocked this in, I was very pleased with the energy of the composition."*

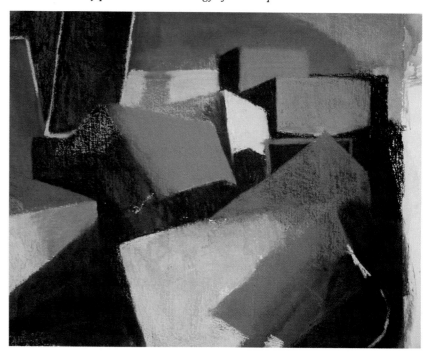

Step 2: *"At this stage I've worked over the acrylic with pastel, further defining the compositional elements. There is much more color in this step—I've begun to play with some warmer colors on the upper boxes. The right side of the piece is blank at this point, but I'm not going to trim the paper yet as I may want to expand the composition into this area."*

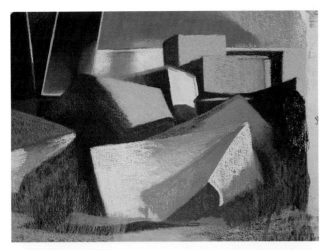

Step 3: *"Here I decided to make a major compositional change to the foreground area. The forms in the lower half of the piece were too strong, almost like they were falling off the surface. To change this area, I used a stiff brush to brush off the pastel. Heavy watercolor paper will take a lot of changes and still hold its texture. I sprayed fixative over the area, then added a foreground and reshaped the front center box."*

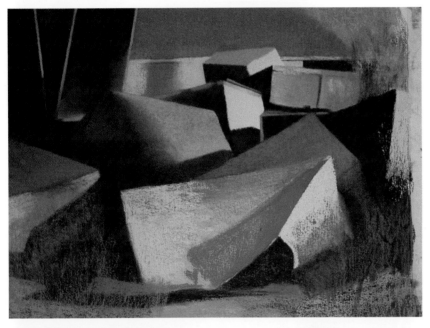

Step 4: *"In this stage I changed the upper, smaller boxes as I wasn't pleased with the previous composition. I wanted more feeling of movement, a tumbling of forms. I made this change, but then felt it wasn't right. The upper box shapes seemed too busy and I was having trouble integrating the background surface of the buildings behind the boxes. Basically all the changes I had made in this stage were to be changed again in the final stage."*

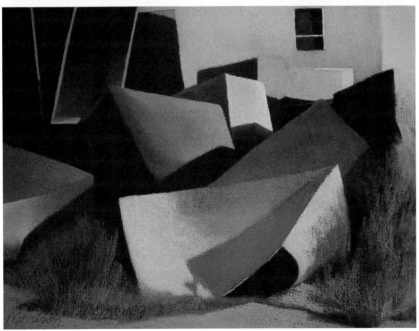

Step 5: *"To finish, the smaller boxes in the upper area were changed again and I've added a large, dark shape to the left of them. The background composition was altered and a window form added to relate to all the shapes in the foreground. The weeds and foreground area allowed me to add some very intense color, bright orange and light red. This arrangement in the lower area seemed to give the forms a sense of place."*

Mary Morrison, *Boxes,* 28″ × 38″

Arranging Flat Shapes of Color

TONY ORTEGA

"I see my work as autobiographical. I grew up in the small, rural town of Pecos, New Mexico. I was raised by my grandmother with the language and culture her family had brought from Mexico. When I became an artist, these memories from my early youth were the foundation of my paintings," says Tony Ortega.

The way that Ortega works is to pick a colorful scene from his travels or current surroundings. (He is more concerned that the subject be colorful emotionally than visually; he often supplies the colors from his imagination.) He then reduces figures, objects, and shadows to flat areas of color arranged in an interesting pattern. He not only simplifies each shape, but also eliminates any shape not essential to the overall design.

He divides the painting process into two stages, the drawing problem and the painting problem. The drawing involves selecting an image, composing it, and putting the forms down on paper. Painting includes refining the forms and developing values and color.

He uses photographs, on-the-spot drawings and his imagination; sometimes he combines all three to develop one subject. He draws the composition first on a sheet of butcher paper, then refines it on tracing paper before transferring it to his pastel paper. This way he can work and rework the image without damaging the paper surface.

This photo shows the scene Ortega used as the basis of the painting. He takes the basic forms from a scene and projects his own sense of color onto the image, thereby expressing the "color" of the relationships and the urban Hispanic experience.

Step 1: *In the first step he blocks out the basic geometric shapes with a pastel pencil, on the textured side of Canson paper.*

Step 2: *Using the side of a pastel, he blocks out the local color of each shape. He strives for final color from the beginning, but knows that some sections will have to be adjusted for value and color temperature. He fills large shapes first and adds spots of brown as a guide to where all the figures are located.*

102

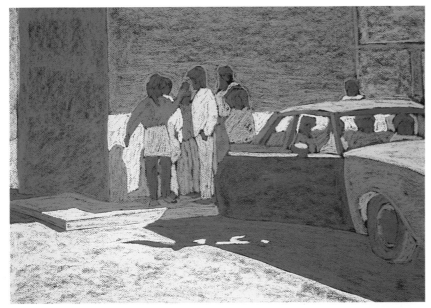

Step 3: *He continues to add color, covering most of the paper now. When he chooses his colors he always keeps the value, light source, size, and color temperature of each shape in mind.*

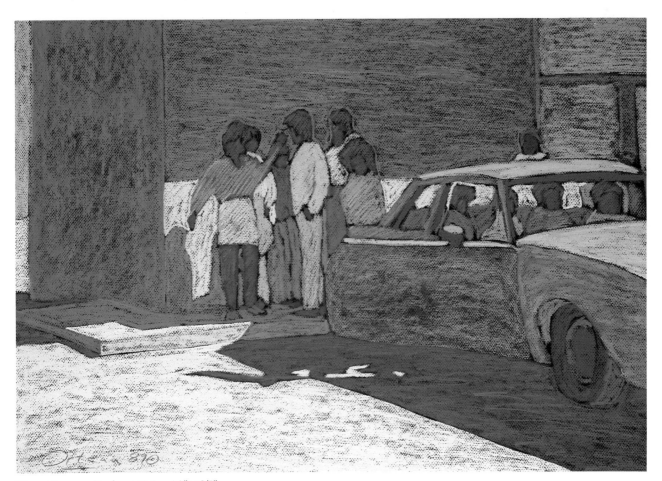

Tony Ortega, *Backseat Vatos,* 19″ × 27″

Step 4: *In some places the color needs to be adjusted for value or temperature. This is done with a second layer of quick, loose strokes using either the end or side of the pastel.*

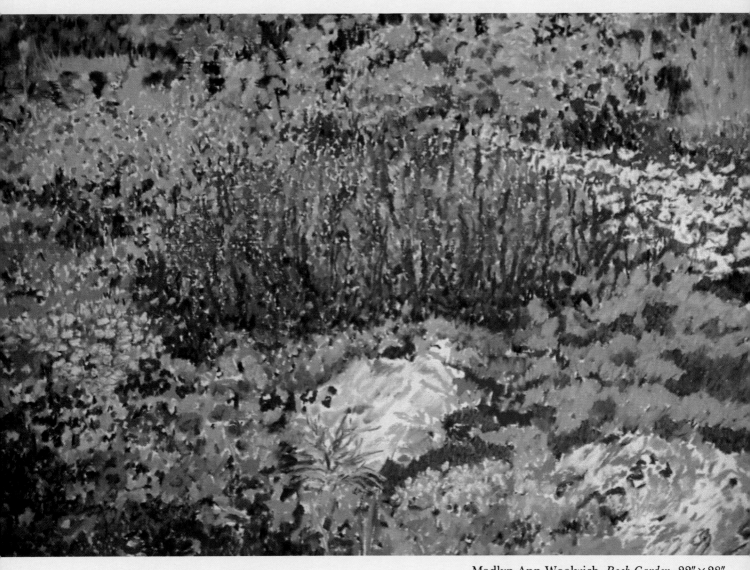

Madlyn-Ann Woolwich, *Rock Garden*, 22″ × 28″

LOCATION
Where and How You Paint

Whether you like to paint indoors or outdoors, from life or from studies, pastel can work well for you. Its versatility is one of its greatest attractions.

I, personally, like to paint with pastels in the studio where my boxes of pastels and supply of paper are readily available. This means I can only work from life when I can bring the subject into the studio—a human model, floral, or still life.

In the past I have taken pastels on location. I vividly remember sitting on the floor of the rehearsal stage of the Denver Symphony Orchestra, my paper and pastels spread out between the cellos and double basses. It worked, but it was cumbersome and messy and I soon

decided to make watercolor studies on location and expand those into pastel paintings in my studio.

More intrepid than I, Elsie Dinsmore Popkin regularly takes her pastels outdoors. She has developed an organized system for virtually transporting her studio out into the landscapes that she paints.

When you work exclusively in the studio, your reference material becomes vitally important. The choices are: painting from life, sketches, photos, memory, imagination, and various combinations of these. The type of reference material can greatly influence the look of your final paintings.

For instance, artists who paint from on-the-spot sketches tend to paint in a looser style, relying heav-

ily on the simplified information captured in quick sketches and memory. Those who work from photographs can be more literal, since they have detailed images as resources.

Painting from life is the classical method of working and is the choice of artists who like the challenge of converting a three-dimensional scene to a two-dimensional image. Having the actual subject before you as you paint is an excellent way to develop your visual skills.

Whichever way you choose to work, indoors or out, from life, sketches, photos, or whatever, pastel will prove to be an accommodating partner.

This is Elsie Popkin's complete set-up for working outdoors in the midst of the lush gardens and woods she loves to paint. For artists who are interested in trying the adventure of painting outdoors, on the next page she passes along her tips for making it as easy as possible.

"For drawing boards I use Homosote, which is light, sturdy, and easy to put pushpins into. I use the extra-long (½-inch) pushpins because they hold in the wind. I cover the smoother side with heavy kraft paper to keep the texture from coming through. Then with an awl or drill I make two holes about two inches apart, on each end of the board about a half-inch from the end. I run clothesline through from end to end, looping it around through the holes so there are two lines running down the back of the board. These can be used to sling the drawing board over my shoulder as I schlepp my equipment to the site."

"Once there, I can secure the board on the easel by hooking an elastic luggage strap around the back leg of the easel and through the little end loops."

"If there is even a hint of wind, I weigh the easel down by putting the legs through bricks with holes in their centers."

"I load the cases onto a large wheeled luggage cart if I have any distance to go with them from car to site."

"I keep my pastels in jewelers sample cases, ordered from Fibre Built division of Ikelheimer/Ernst, 601 W. 21st St., New York. It's better to get two shorter ones than one tall one, as they are heavy when filled. I line the bottoms with thin foam to cushion them. I use a piece of foam insulation with a hole cut out for the handle, placed on the bottom case so the cases can be stacked."

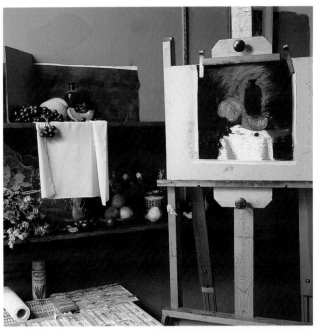

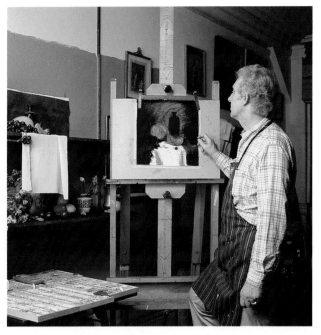

This is Richard Pionk's studio with a painting in progress. On the left is the set-up of the subject. The wooden partition provides a dark background and prevents any light falling on the subject except from above. On the lower shelf are an assortment of objects to be used for later paintings. The table holds Pionk's trays of 500 to 600 pastels.

Here we see Pionk working in his studio. He advises, "Don't sit to work if you can stand. Stay at least an arm's length away from your pastel board. Back away and study your work for as much time as you paint."

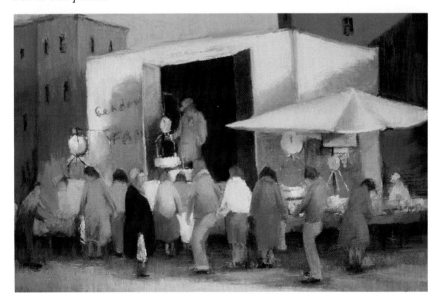

Sidney Hermel, *Greenmarket,* 22″×30″

This painting was done in the studio from on-the-site studies.

107

Taking the Studio Outdoors

ELSIE DINSMORE POPKIN

Popkin says, "Until 1982 I worked almost exclusively with the figure, using models, nude or costumed. That year, in response to an invitation to participate in a landscape show, I began to work from nature. By the time I finished the required works, I was hooked on landscape. I relished the challenge of searching out compositions in nature after all those years of arranging models and props in the studio. I realized that the sunlight and shadows in the living landscape created colors much more vivid and subtle than I could possibly invent in the studio. And I discovered a total immersion in the lush landscape; never having to stop for a model to rest freed me to work more intensely and spontaneously."

Popkin has developed the materials, tools, and painting technique to take full advantage of the extensive range of outdoor subjects. All her painting equipment is portable. She simply finds a subject and sets up her studio there.

She says, "I work on site to capture the light and colors in the landscape with an immediacy and intensity only possible when I am racing the sun and seasons to completion. I try to express in my pastels the essence of the landscape I am painting. I want the viewer to experience the same deep satisfaction I feel upon completion of the work. And I hope that the experience of seeing my pastels will open the viewer's eyes to his own surroundings, will help him to see and rejoice in the forms and colors and beauty of the world around him."

This photo of the subject was taken on the first day of painting. By the time Popkin finished, the spring foliage was much more lush.

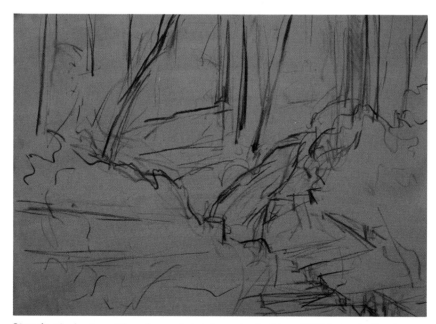

Step 1: *She begins with a charcoal sketch on sturdy Rives BFK paper indicating placement of path, trees, and bushes. The greenish tone is an acrylic-marbledust wash applied to the paper earlier.*

108

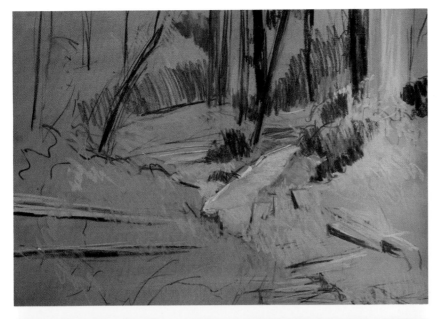

Step 2: *With her hardest pastels she blocks in the large shapes that organize the composition. Notice that from the beginning she uses a variety of strokes, but all larger than those that will finish the piece.*

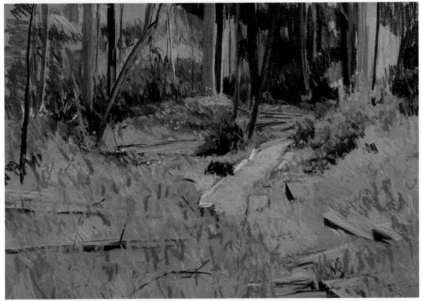

Step 3: *She works over the entire surface, painting most densely in the background where the darkest values are. She looks for patterns in the shapes, the parallel lines of trees, the diagonal rows of pink flowers in the lower left.*

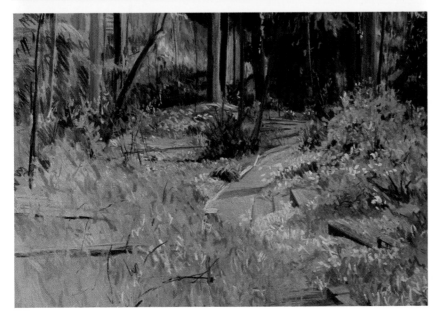

Step 4: *She now develops the colors and textures of the flowers. The pattern of sunlight begins to show. She leaves the strokes unblended, finding that blending blurs and dulls the colors.*

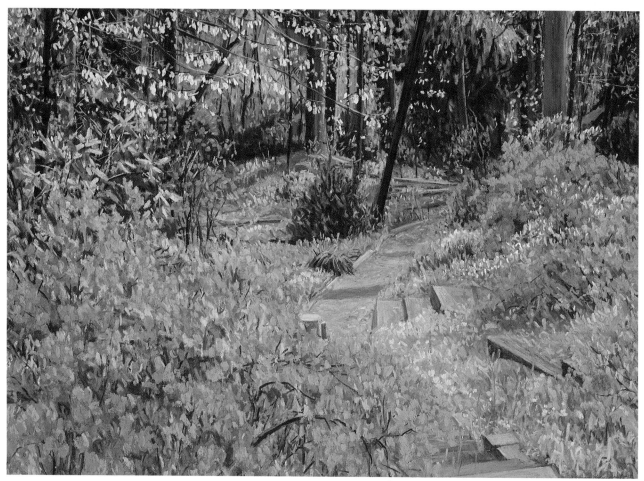

Elsie Dinsmore Popkin, *Pat's Garden
with Carolina Silverbells*, 22″ × 30″

Step 5: *"At last I can begin to have fun," says Popkin, "for now that the darks have
been dug out, I can start to 'embroider the surface.' I keep the can of fixative spray in
my right hand, the chalks in my left." Sometimes, for a more "painterly" stroke, she
works into the wet fixative. The painting is finished with equal attention to detail and
brilliance throughout.*

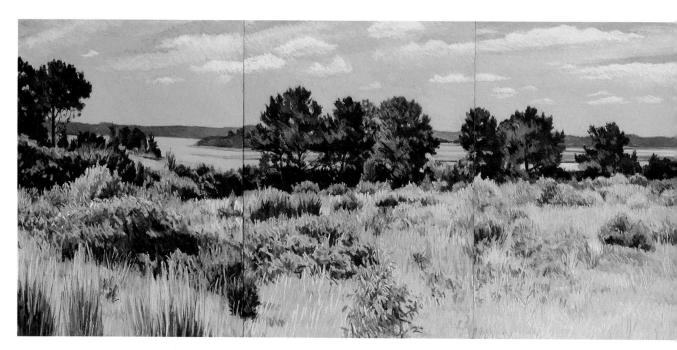

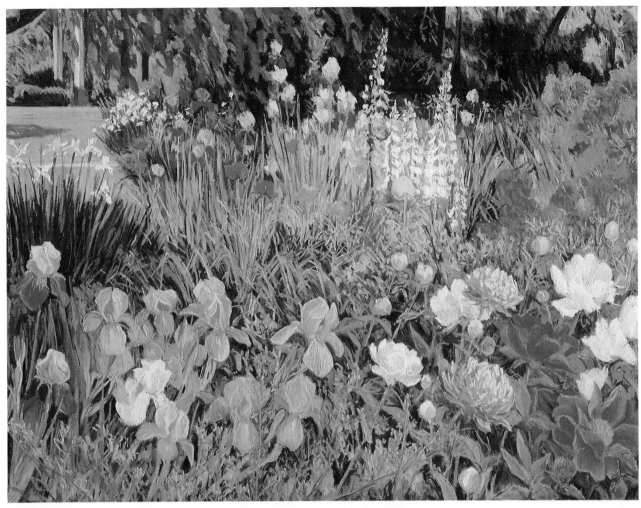

Elsie Dinsmore Popkin, *Dr. Spur's May Garden—Irises and Peonies*, 38″×50″

Working outdoors has its disadvantages. Popkin explains, "I almost always work from life. Since one can never count on the weather cooperating for long, I dare not take the time to do extensive studies, so my preliminary sketches are all in my head. I often take photographs of the site as I begin, in case of a freeze or heavy rain, but usually the picture is done before I've gotten the film developed."

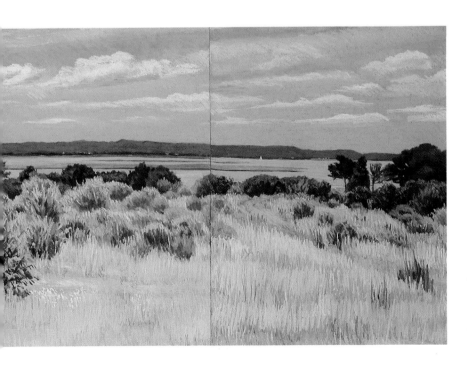

Elsie Dinsmore Popkin, *Bogue Inlet Panorama*, 30″×110″ (five panels, 30″×22″ each)

"At the North Carolina beach in June," says Popkin, "I painted one panel per day, working from 10 A.M. to 6 P.M. When I got back to my studio, I pinned all five panels on the wall and matched up the clouds, water, and islands."

111

Painting the Town

SIDNEY HERMEL

New York City is an ever changing, ever challenging subject for artist Sidney Hermel. He fills his compositions with the people, architecture, activity, color, even a sense of the noise of the city. He has developed a style that captures its spirit.

He finds his particular subjects on the streets, where he draws and paints the small studies that form the basis of his work. With quick lines and washes he captures urban moments. Later in his studio he expands the on-the-spot sketches into fuller color studies and finally into finished paintings. Occasionally he uses photos for additional reference, but the sketches and his personal knowledge of the city are always his primary resource.

In his studies he has time only for noting gestures, basic value relationships, and impressions of color, so these become the components of his finished paintings — no labored rendering or subtle lighting effects for Hermel.

One of the problems he faces is integrating the figures and the buildings with the overall design. A method Hermel uses to unify the image is letting the colors flow from one object to another, avoiding outlines, and using more soft edges than hard. However, technique remains secondary to his subject. He spends a great deal of time meandering through the small streets of his exciting city, always on the lookout for an interesting subject to be used in his next painting.

The first step for Hermel is picking a subject. He was attracted to the light, colorful backdrop of the newly exposed rear building as well as the stark barrier of the fence. He says, "The color, shapes, and attitudes of the sidewalk 'supers' sent signals to me. I sketched the scene using felt-tip pens, my favorite sketching medium."

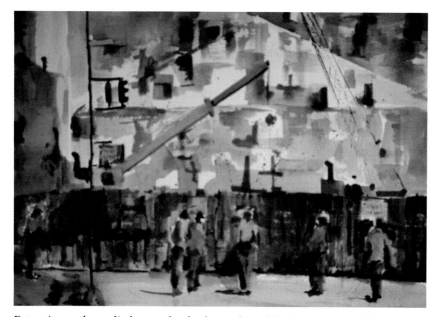

Returning to the studio he completed color studies while the scene was still fresh in his mind. This watercolor sketch shows the large scene; he decided that his greatest interest was actually in the spectators, the "sidewalk superintendents." So he planned a larger painting focusing just on them.

Step 1: *Working on Hermes cloth sandpaper he paints in the composition with a well-diluted mixture of oil paint and turpentine. Here we see a section of that loose underpainting where he concentrates on color, value, gesture, and placement of shapes rather than details of anatomy or architecture.*

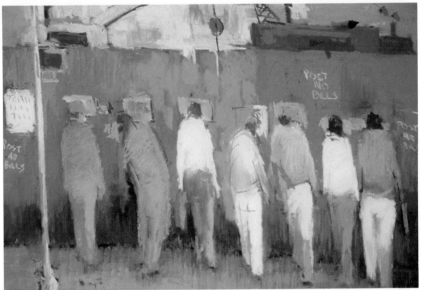

Step 2: *He says, "Starting with NuPastels I laid in the figures, fence, and background always with an eye for the color unity and for any visual device that would allow me to strengthen the structure and design of the painting. In some instances I allowed the background to move through the figures in order to fully integrate them into the painting, and avoid the look of being merely 'pasted' on. I introduced the colors of the yellow and red cranes into the foreground figures, contributing to color unity. At this point I began to use the softer Rembrandt pastels, reinforcing color and value and further adding to the textural quality of the painting."*

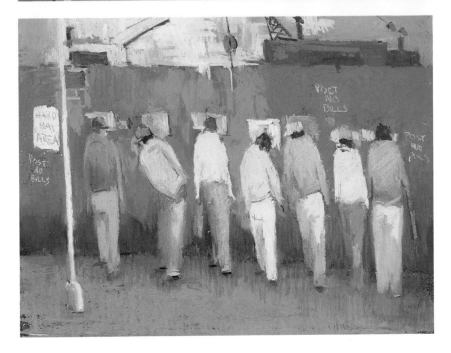

Sidney Hermel, *Sidewalk Superintendents,* 14″ × 18″

Step 3: *In the final painting you can see that the figures are definitely the focus of the composition, with just enough background information to tell their story. Throughout the piece the strokes are bold and lively and the color is imaginative, as in the violet highlight on the machinery. The rough tooth of the sandpaper allows a dense build-up of color.*

113

Bringing the Subject Into the Studio

Step 1: *"I start with a triangle and fast gesture drawing with medium vine charcoal, developing objects slightly off center. This pastel is painted on sandpaper."*

Step 2: *"I block in and correct the drawing with charcoal, wiping out lines and smoothing areas with my fingers. I am interested in the large shapes with no thought of detail here."*

RICHARD PIONK

Richard Pionk is, like Sidney Hermel, a New York artist, but he prefers to work exclusively in his studio where he sets up and paints his beautiful still lifes. Using the traditional method of setting up the subject and working from life, Pionk has maximum control of the choice of objects, placement, and lighting.

Pionk says he chose his studio because of the north window, which provides a source of unchanging light. He has blocked off the lower part of the window to give the light a downward direction as if it were coming from a skylight.

He explains, "I am especially interested in the effects of light. In chiaroscuro painting the eye follows the light, going from one section to another, and the shadows structure the painting. I usually let the light come in from the left to the focal point. The background is dark and the light on objects gradually gets brighter as it moves to the right."

This interest in light is one of the reasons his paintings have a classical look. Another is his method of working from value to color. Working on a variety of surfaces, he begins each painting with a charcoal drawing to place shapes and values, and then goes on to blocking in shapes of color.

He builds up his colors with strokes of French pastels which he prefers for their softness and brilliance of color. In between workings of pastel he sprays lightly with fixative, holding the can about 12 inches from the surface. He warns that too much spray can darken the pastel. Occasionally he deliberately darkens an area by masking it off and spraying it. He says, "The darker the area, the more drama."

Step 3: *"I then start with hard pastel, blocking in the basic colors with corrections as I see the need for them."* He often draws his strokes from left to right to reinforce the direction of the light.

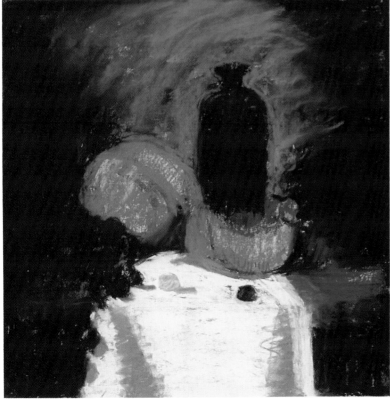

Step 4: *"I continue to fill in the large shapes with hard pastel, using the side of the pastel and light pressure on the pastel stick, working from dark to medium to light. This is the sequence I use in doing all my pastels."*

115

Step 5: *"I begin to pull out more objects by basic shape and additional color, sharpening up some edges for more clarity. In the finished painting some edges will be hard and others soft depending on location and lighting."*

Richard Pionk, *Melon and Grapes,* 15″ × 15″

Step 6: *"I give the surface a light spray of fixative and move to soft pastels, giving only the necessary detail. I constantly have the thought of focal point in mind (the large melon piece). The dark grapes and melon slice act as a frame to pull the eye to the lighter, larger melon. The background is given a rich balance of shape and color. The single grapes are given added detail due to their closeness. A final light spray of fixative is applied."*

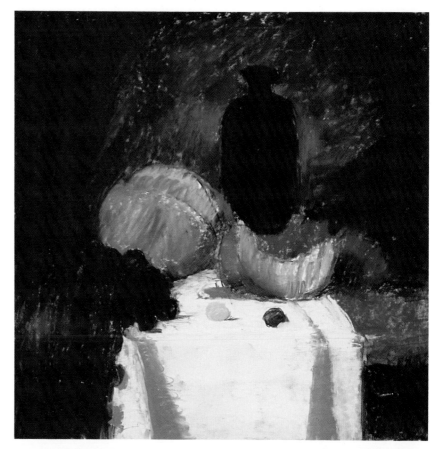

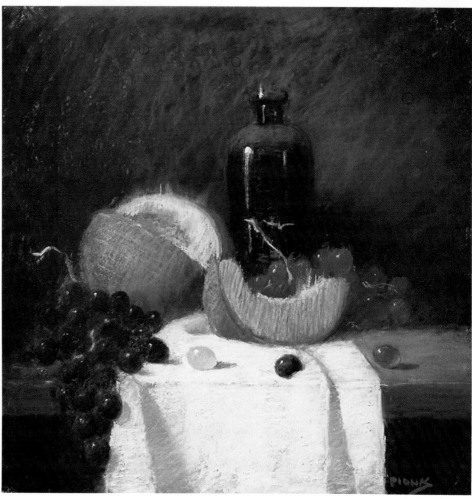

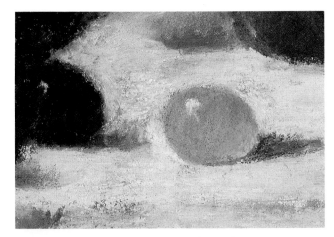 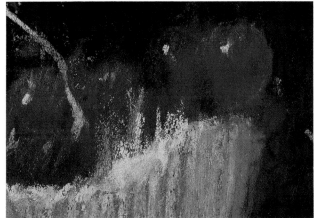

In these details you can see how Pionk merely suggests some shapes while he carefully renders others. Those that are closer and in more light will be more precise. For softer edges he either draws rough strokes of pastel or blends the stroke slightly with a finger.

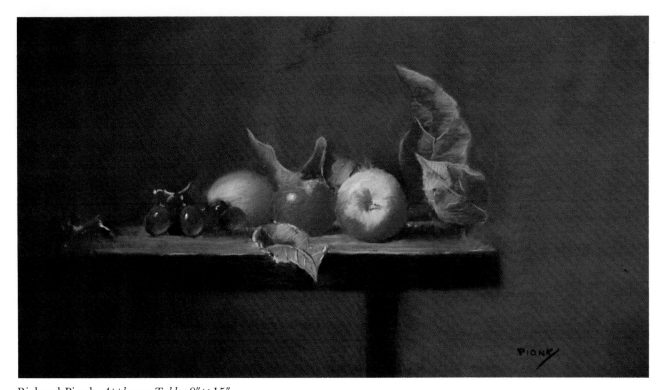

Richard Pionk, *Apples on Table,* 9″ × 15″

This is a simple composition that focuses on the intrinsic beauty of each piece of fruit. There are no tricks or gimmicks in Pionk's work, only deft craftsmanship combined with great patience and concentration.

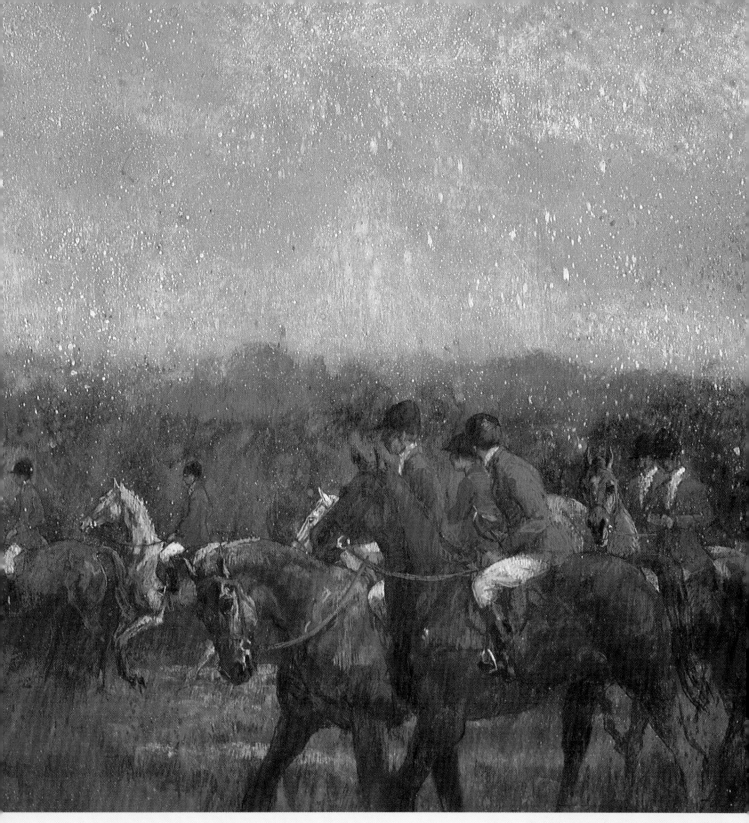

Fay Moore, *Hunter's Return*, 48″ × 48″

CORRECTIONS
The Freedom to Experiment

Pastel is a very forgiving medium. It is a great medium for experimentation and emotional expression because it allows you to correct almost any error.

I am a very spontaneous painter with pastel, so I am constantly having to alter or cover up things that didn't quite work. The result is that I have found lots of ways to correct errors.

It is liberating to know that any stroke you apply can be altered, any value can be adjusted, any color can be changed. This allows you to take chances, experiment, push yourself to your furthest vision. Some of the most imaginative art I've ever seen has been done with pastel—and some of the most conservative. Pastel gives you that choice.

Barbara Geldermann Hails,
Low Bridge, 24″ × 30″

In the early stages of this painting there was a figure walking down the path. Hails decided that it detracted from the total composition, so she simply covered it up with several layers of pastel strokes.

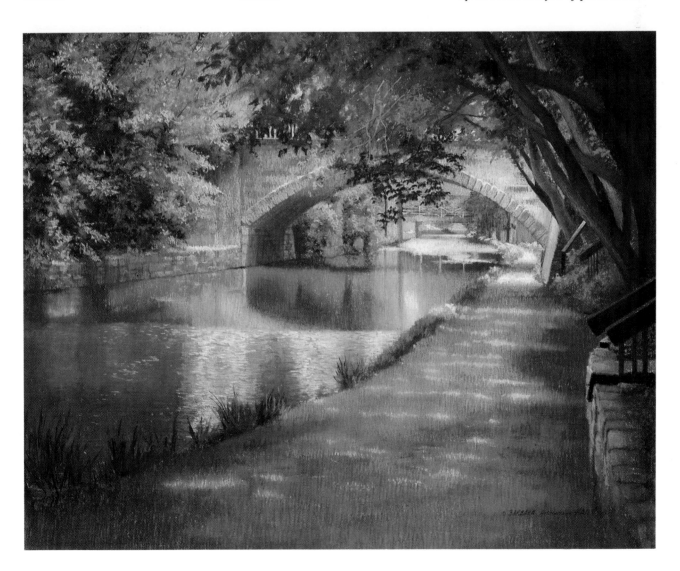

Madlyn-Ann Woolwich, *Twilight Beach*, 18″ × 24″

During the painting of this piece Woolwich says the rocks got too smooth, so she "sprayed and worked and sprayed and worked until they got a textural, crumbly look to them."

METHODS OF CORRECTING MISTAKES

Rubbing. Using a cloth, paper towel, or a tissue, rub the pastel off the offending area. This will eliminate incorrect contours, soften values and colors, and remove unwanted layers of pastel build-up. You can also blend the pigment into the paper with your finger, making it easier to cover with new strokes.

Brushing. Brushing an area with a dry, stiff-bristled brush will accomplish many of the same things as rubbing, while loosening and lifting off unwanted pigment.

Scraping. For small areas of hard pastel you can scrape the pigment off with a knife or scalpel. Be sure to use a light touch so you don't damage the surface.

Erasing. On early layers of pastel, or after you have brushed off thick layers of pigment, a kneaded eraser will remove much of the remaining tone, often taking the paper back to its original color. (I also use the eraser as a drawing tool. In areas of blended color, I draw with the eraser, leaving strokes of the original colored paper underneath.)

Wetting. With a wet brush (using water, or turpentine or some other solvent) you can liquify an area of color. This blends the existing colors and returns the surface to a more workable form. Be sure that your surface is compatible with the particular liquid. Water will make a light-weight paper buckle and may lift the sand off of sandpaper.

Painting. If you like mixing different media, you can obliterate an area of pastel by painting over it with opaque strokes of acrylic, oil, or gouache. Keep the paint fairly thin so you don't lose the basic texture of your surface. Use oil only on a surface that is suitable for oil. Also be careful not to use a water-

based paint over an oil-based underpainting. The water-based paint will not stick over oil.

Fixing. To return a heavily pasteled area to a receptive surface, spray with workable fixative. Use several light to medium coats of spray, allowing each to dry before adding another. Spray with the painting upright and the can at least twelve inches away to avoid large spots of spray. When the final coat of fixative is dry, your previous image will still be visible, but it can be covered with new layers of pastel.

If only part of the painting needs to be sprayed, cover the rest with paper while you spray. Spray fixative tends to darken pastel, often eliminating highlights entirely, so it can be used to deliberately darken sections of a painting that are too light in value. Again, be careful not to spray too heavy a coating or the surface will acquire a plastic look.

Covering. You can hide strokes of pastel by painting over the area with a stick of softer pastel. This only works up to the point where the surface becomes saturated with pastel and won't hold any more. At that point you can resort to fixative.

Mary Morrison, *Summer Market*, 29″ × 43″

Morrison allows herself the freedom to let each composition evolve during the painting process. She uses fixative to get a continuously receptive surface on which she can alter or eliminate anything that has gone before. To remove heavy areas of unwanted pastel, she takes the painting outside and brushes the unwanted area with a stiff brush.

Texture, Texture, and More Texture

FAY MOORE

Fay Moore comes from a classical art education where she learned to build up an image with many transparent layers of color. She says, "I think what gives interest is the layering of many traces of colors and textures. Whatever went on underneath contributes, enriches, and is not lost."

In her paintings of horses there are many different realities—the anatomy of the horses and riders, the abstract design of color and value, and the story of the race itself. These layers of concept make her layering of color even more appropriate.

She says of her style, "I have developed it entirely on my own with the objective that I apply to all media—to bring to representational painting as much painterly freedom and excitement as I can without losing the image."

She says she often creates "happy accidents" in areas that are boring by putting water on the pastel so the pigment flows around it in its own kind of wash. Then she works back and forth with pastel and watercolor until she achieves the desired image.

Moore says, "For me there is no such thing as an overworked area. When I don't like the area (after the whole painting has been quite developed, one likes certain areas better than others!) I pat on quite a bit of water using the side of a brush or a crumpled towel. The pigment floats around and settles in a different way, but whatever was there before always shows through a bit and contributes to whatever I do after it is all dried."

She uses very little fixative, but "spanks" the panel briskly at the end of a work period to remove loose pastel dust.

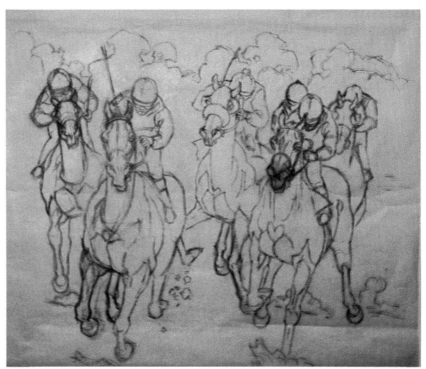

Step 1: *Moore makes a number of rough charcoals on successive layers of tracing paper. The last one is in charcoal pencil for more detail and sprayed with fixative for transfer by carbon to the ground.*

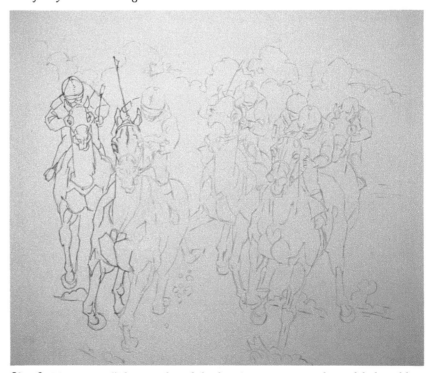

Step 2: *Moore says, "I have carboned the drawing onto mounted pastelcloth and have begun the final re-drawing with a red waterproof pen. Anatomy is all accurate by now, so I try to give these lines a lot of freedom and style as some will show through in the finished painting."*

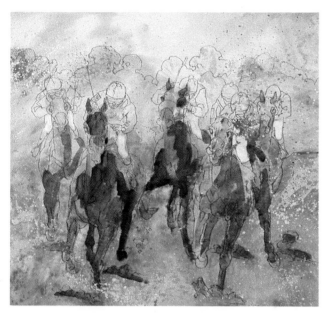

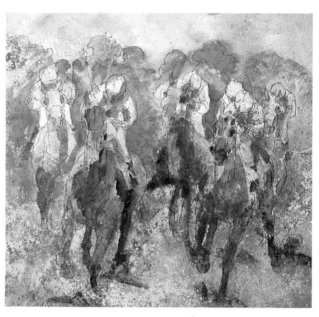

Step 3: *Next she adds gouache and watercolor washes, establishing basic colors and marking the lightest and darkest spots in the composition. She spatters in more color, wet and dry, to enrich the surface texture and establish color temperature.*

Step 4: *Here she adds more washes and colors, and more sprinkles of light and dark.*

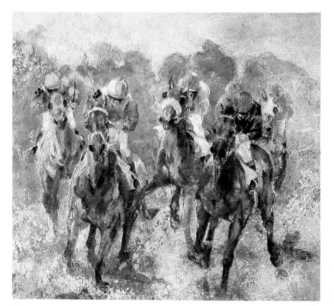

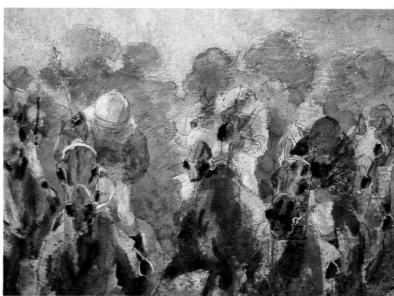

Step 5: *Moore decides on the colors of the racing silks and adds the first strokes or scumbles of pastel.*

Step 6: *(Detail) At last she brings in spots of pastel to enrich colors and values. The pastel is applied in hard strokes or in softer scumbled areas. In places it is blended with a drawing stump to model an area or integrate the pastel with a passage of watercolor.*

Fay Moore, *Summer Stakes Race,*
32″ × 34″

Step 7: *"Now I want more dark on the
ground, so I lay in some loose washes in
the lower corners. (See details below.) I
add another layer of distant trees and also
use a dark brown wash on some necks and
legs. These run a bit and break past the
outlines. So I add some free outlines on
top of these new washed areas to keep the
look of spontaneity going to the last."*

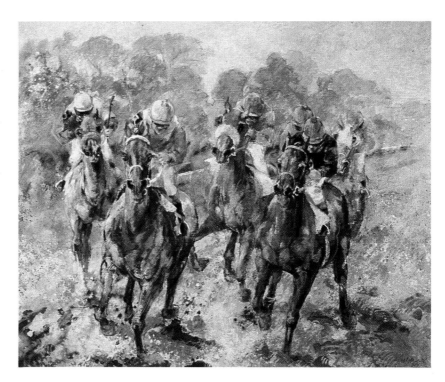

*These three progressive details show how the artist develops some
darker values with additional washes and pastel strokes after she
is well into the painting.*

124

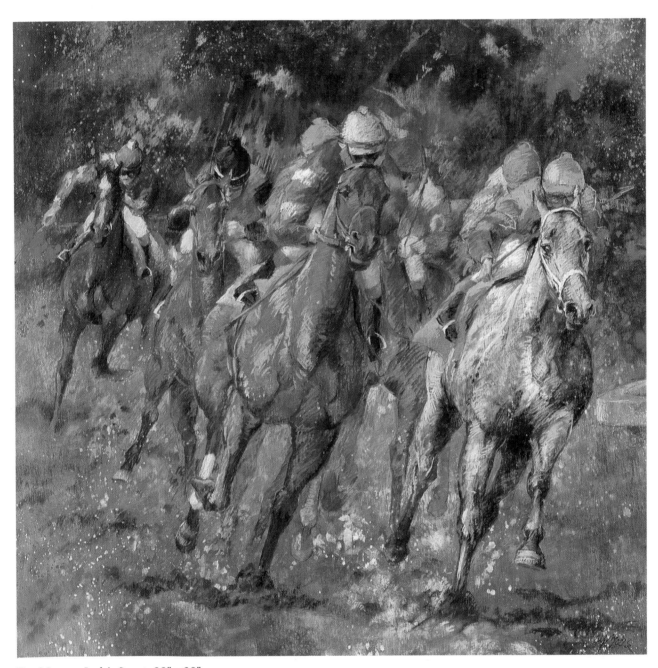

Fay Moore, *Lady's Secret*, 38″ × 38″

In this action-filled race painting, the linear pastel strokes are quite obvious. In order to unify the textures, Moore also includes some definite pastel strokes among the washes and spatters of the foreground and background.

Using Whatever Works

Step 1: *I began this piece over a failed pastel on Fabriano Morilla paper. The paper was strong enough for me to brush off the old pastel with a rag and to withstand the use of a wet medium. I start with an initial drawing with a brush and acrylic.*

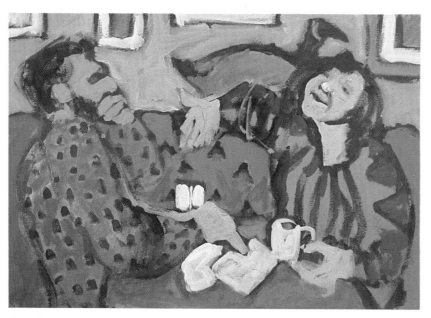

Step 2: *With just a few colors I paint in acrylic washes to cover the main areas. I keep the strokes loose to help create an interesting surface texture. The purpose of this piece is to show the relationship between the two people (she was trying to sell radio advertising time to a potential buyer over breakfast in a neighborhood coffee shop) so I was most concerned about the gestures and placement of the two figures.*

CAROLE KATCHEN

In my own paintings my main concern is the subject, usually people, with the focus on the interaction between those people. My favorite medium is pastel because I can push it in whatever direction will best express the scene.

One technique that I enjoy is combining pastel with acrylic, alternating layers of the two media throughout a painting. I developed this technique during one of those moments of desperation when I was ready to throw my painting or myself out a window. I painted over a chaotic area of pastel strokes with an opaque acrylic wash. It worked, smoothing out the color and leaving me with a workable surface.

Since then I have taken the process further, establishing large areas of color with acrylic and then refining with pastel. I often use this technique over a failed pastel.

During the course of a painting, I rely on fixative to restore a workable surface or to build up layers of blended color. At the end I spray several very light coats on the piece to preserve the surface.

My philosophy about painting is that it should be a joy and an adventure. So I have as much fun as I can and still get the job done.

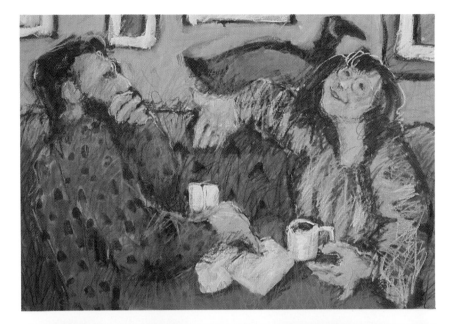

Step 3: *Using pastel I work over the entire surface with a loose stroke. I use pastel colors that harmonize with the acrylics because I am trying to establish solid color shapes.*

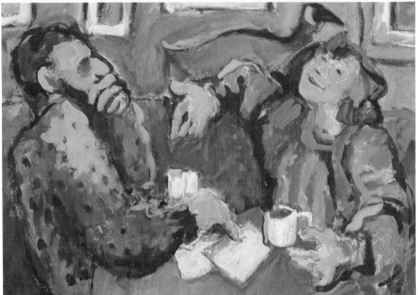

Step 4: *The colors were too flat and dull, so now I liven them up with more variation of value and color. I work loosely with acrylic, letting some of the pastel strokes remain. By using thinner washes and scrubbing the acrylic into the surface, I can blend the acrylics with the pastel color.*

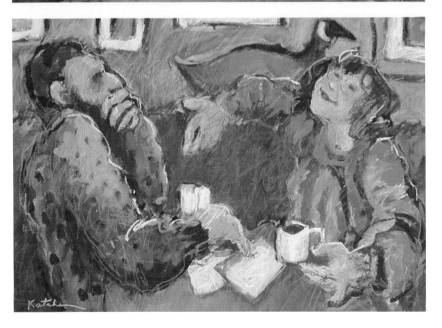

Carole Katchen, *Soft Sell,* 27½″ × 39″

Step 5: *Again covering the entire surface with pastel strokes, I achieve my final colors and textures. In areas where I want a smoother surface, like the faces, I use pastel to eliminate the separation of paint strokes. In other areas, his sweater for instance, I let paint and pastel strokes sit separately for maximum vitality. For more visual interest I add bright accents of pastel in contrasting colors.*

Looking through this book you can see the tremendous variety of styles and techniques available to pastellists. I have presented 20 different artists here. Each one has a unique vision and each one has been able to develop that vision in pastel.

To recap, the materials themselves offer vast choices. From the precision of pastel pencils to the lush expressiveness of soft handmade sticks, the form of the pigment itself can guide your creativity.

The application of pigment affects both mood and image with a range as broad as the staccato strokes of cross-hatching to the subtle elegance of smoothly blended layers of color.

All of the components of any painting — color, value, composition — can be fully treated with pastel and often in new, imaginative ways. Perhaps most important of all, pastel is a very forgiving medium. It allows you the freedom to experiment knowing that mistakes can be covered up or changed.

For me, being an artist is a process of growing. I am constantly learning to see in new ways; my vision becomes more refined as does my technical skill. Pastel is a special medium because it grows right along with me.

If you have never worked with pastel, give it a try; it might be the perfect medium for expressing your own vision. If pastel is already your medium of choice, experiment, be adventurous, be outrageous. The only limits for pastel are the limits of your own creativity.

The following pastel colors have been determined to contain some toxic substances. The particular substance is noted next to the color with an added note (*) for extremely dangerous colors which should be avoided or used with unusual care. This is not necessarily an exhaustive list because of the very many pastel colors available from many different manufacturers, as well as the fact that new information is continually becoming available. It should also be noted that some colors have retained traditional names (such as Naples Yellow), though a new chemical blend has been developed, excluding the most toxic elements. Often both types are available, so it is advisable, when in doubt, to check with the manufacturer.

Zinc Yellow: chromium in the form of zinc chromate

Cadmium colors (yellow, orange, red, etc.): cadmium

Naples Yellow (true color): lead antimoniate*

Chrome colors (especially yellow): lead chromate*

Lead Red: lead*

Cobalt Violet: cobalt phosphate or arsenate* (the arsenate type should be avoided)

Other cobalt colors: cobalt

Vermilion: mercuric sulfide

Cerulean Blue: cobalt and tin oxides

Emerald Green: traditional color contained arsenic* (should be avoided); newer brands do not—check with manufacturer

Raw Umber: manganese silicates

Burnt Umber: manganese dioxide

Mars Brown: manganese dioxide

Other manganese colors

OTHER GENERAL PRECAUTIONS

- Always wash hands well after working or intermittently while working if your hands have a lot of contact with the materials.
- Avoid eating or smoking while working with pastels.
- Avoid breathing pastel dust as much as possible. If you tap or blow on your pastel work to remove loose dust, it is best to do this outside of your studio and to wear a mask during this or other procedures that cause a lot of airborn pastel dust. An electric air filter is also an advisable addition to your pastel studio.
- Spray fixative should not be used in the studio, if at all possible. The cumulative effects of inhaled fixative can be very serious. Proper ventilation, or even better, outdoor use, is highly recommended. Care should also be taken not to use fixative around pets or small children.

For additional information on art material hazards, contact the
Center for Occupational Hazards
5 Beekman Street
New York, NY 10038
212-227-6220

If you are unable to find an art material mentioned in this book, the following manufacturers may be able to direct you to a source of supply in your area.

Bienfang
Hunt Manufacturing Co.
230 S. Broad Street
Philadelphia, PA 19102

Conté
Hunt International Co.
1405 Locust Street
Philadelphia, PA 19102

Crescent Cardboard Co.
P.O. Box XD
100 W. Willow Road
Wheeling, IL 60090

Duro Art Industries, Inc.
1832 Juneway Terrace
Chicago, IL 60626

Fabriano America, Inc.
P.O. Box 10210
Lansing, MI 48901

M. Grumbacher, Inc.
460 W. 34th Street
New York, NY 10001

LeFranc and Bourgeois
Zone Industrielle Nord
BP337
72007 LeMans Cedex
France

Morilla, Inc. (Canson-Talons)
21 Industrial Drive
South Hadley, MA 01075

Rembrandt
Royal Talens BV
P.O. Box 4
7300 AA Apeldoorn
Holland

G. Rowney & Co.
P.O. Box 10
Bracknell
Berkshire RG12 4ST
United Kingdom

H. Schmincke & Co.
P.O. Box 3120
D-4006 Erkrath
West Germany

Sennelier
Rue du Moulin-A-Cailloux
Orly
Senia 408
94567 Rungis Cedex
France

Strathmore Paper Co.
So. Broad Street
Westfield, MA 01085

Dianne Townsend
Handmade Soft Pastels
385 Broome Street
New York, NY 10013

Going Up Berthoud (collection of Dr. and Mrs. W. Meacham), *Near Times Square* (collection of Mr. and Mrs. J. Silverman Jr.), *The Denver Parish* (collection of Dr. and Mrs. W. Meacham), *Berthoud Woods* (collection of U.S. West Telephone Company), *Elizabeth's Daughter*, copyright © by Doug Dawson. Used by permission of the artist.

Bill Eating Watermelon © 1986, *Chum's Back* © 1987 (collection of Maxwell Davidson Gallery), *Immaculate Grinding Wheels* © 1988 (collection of G. Gund), *Dorinne Seated with Mirror* © 1986 (collection of Maxwell Davidson Gallery), *Dorinne with Pearls* © 1989 (collection of Sande Schlumberger), *Kate Reclining* © 1987 (collection of Carol Jones), copyright © by Deborah Deichler. Used by permission of the artist.

Bellbrook Creek in Winter, Morning Marsh, Morning Light, Daybreak on the Stillwater, Winter Warmth, January Shadows, copyright © by Robert E. Frank. Used by permission of the artist.

Solitude © 1986, *Boardwalk through the Dunes* © 1988, *Gate Vista* © 1984, *The Lock* © 1986, *Azalea Bank* © 1988, *Low Bridge* © 1986, copyright © by Barbara G. Hails. All in private collections. Used by permission of the artist.

Tonight at Vancouver © 1983 (collection of Jerry Kirk, San Francisco, CA), *Santa Monica Bay* © 1985, *Nice Sunday* © 1981, *Hollywood 101* © 1982 (collection of Barry Meek, Los Angeles, CA), *Windy Day* © 1985, copyright © by Christian Heckscher. Used by permission of the artist.

Greenmarket, Horseshoe Bay, Bermuda, Piazza San Marco, Pete's Tavern, On the Avenue, Kim's Market, Sidewalk Superintendents, copyright © by Sidney H. Hermel. Used by permission of the artist.

At the Flea Market © 1987, *Still Life in Blue and Gold* © 1988 (collection of Mr. and Mrs. Joseph Francis), *Bryan in the Pool* © 1989, *Outside Leesburg* © 1989 (private collection), copyright © by Bill James. Used by permission of the artist.

Still Life with a Blue Pitcher © 1988, *Gourds and Onions* © 1983 (private collection), *Still Life with Three Eggs* © 1989 (private collection), *White Still Life* © 1979 (private collection) copyright © by Jane Lund. Used by permission of the artist.

Side Gardens, End of Summer (collection of Carol Duemler, Pasadena, CA), *Morning Patterns, Asheton House* (collection of Shawn and Susie Collard, Tujunga, CA), *Atwood Lane in Snow, Winter Sun* (collection of Pat and Greg Kowalski, Pasadena, CA), *Autumn Skies: Sunset on Alden St.* (collection of Robert Pompa, Pasadena, CA), *Atwood Lane, New Snow* (courtesy of Lizardi/Harp Gallery, Pasadena, CA), *New Shoes* (collection of Moe Van Dereck, Provincetown, MA), copyright © by Simie Maryles. Used by permission of the artist.

Woman with Red Hair © 1988, *Blue Table/Striped Chairs* © 1988 (collection of Ed O'Dell), *Woman at the Bar* © 1989 (collection of Mr. and Mrs. David Meissner), *Window Table* © 1989 (collection of Mr. and Mrs. G. Richard Hanor), *Waiters Setting Up* © 1988 (collection of Harry Pelz), copyright © by Jody DePew McLeane. Used by permission of the artist.

Seattle Slew © 1987 (collection of Mr. Harry Cohen), *Hard Scuffle* © 1989 (collection of Brown Forman Corp.), *Summer Stakes Race* © 1989 (collection of Brown Forman Corp.), *Lady's Secret* © 1988 (collection of Mr. Michael Harrison), copyright © by Fay Moore. Used by permission of the artist.